Innovation in DVD Packaging Design

Charlotte Rivers

RotoVision

Innovation in DVD Packaging Design

Charlotte Rivers

A RotoVision Book

Published and distributed by RotoVision SA
Route Suisse 9
CH-1295 Mies
Switzerland

RotoVision SA
Sales and Editorial Office
Sheridan House, 114 Western Road
Hove BN3 1DD, UK

Tel: +44 (0)1273 72 72 68
Fax: +44 (0)1273 72 72 69
www.rotovision.com

10 9 8 7 6 5 4 3 2 1

ISBN: 2-94036-108-8

Art Directors: Luke Herriott and Tony Seddon
Design: Simon Slater, www.laki139.com

Printed in China by Midas Printing International Limited

Contents

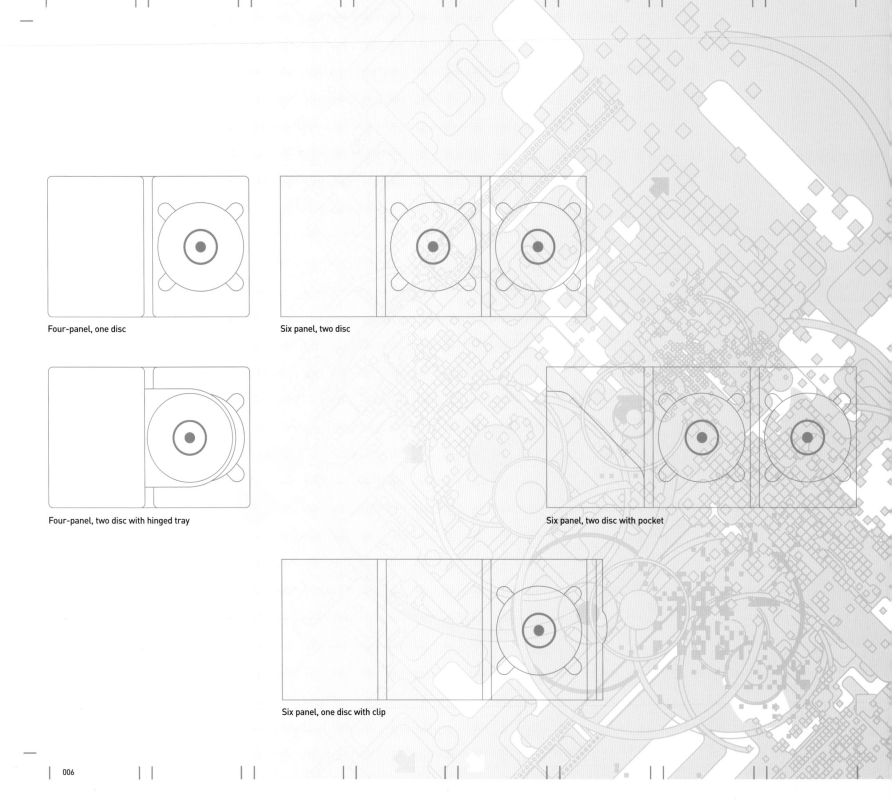

Four-panel, one disc

Six panel, two disc

Four-panel, two disc with hinged tray

Six panel, two disc with pocket

Six panel, one disc with clip

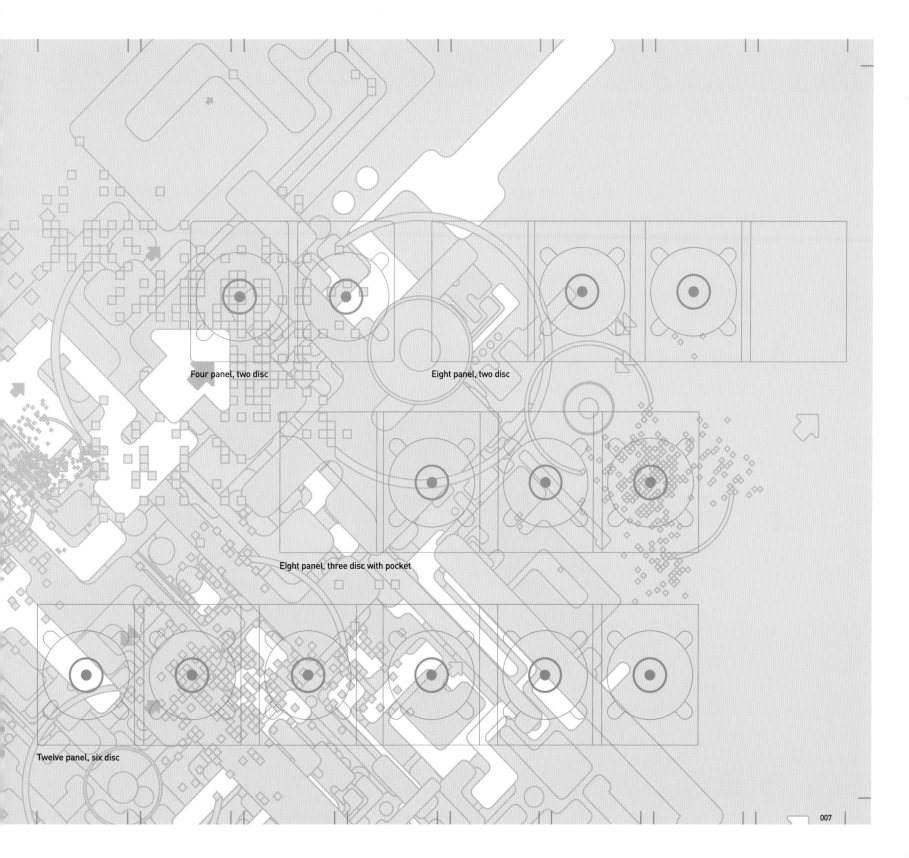

Four panel, two disc

Eight panel, two disc

Eight panel, three disc with pocket

Twelve panel, six disc

01

"Special packaging would be the best way to save the physical DVD from dissolving into the downloadable world."

Todd Gallopo, Creative Director/Chief Executive Officer, Meat and Potatoes, Inc.

Introduction

When I wrote CD-Art in early 2003, I mentioned the imminent arrival of digital music, but I did not imagine that its arrival would be so fast and have such an immediate impact. With the increasing popularity of the MP3 player—we've had the iPod, mini iPod, the iPod shuffle—and the success of the download industry, the numbers of legal downloads are set to rise even higher. This proves that, despite initial concerns over illegal downloads, if controlled and regulated, record labels and artists can indeed profit from the digital format. And consumers, of course, can get music tracks at the click of a button.

However, one problem the increasing popularity of downloadable music has posed is how to keep consumers buying music in-store? Music companies have had to look at ways of encouraging consumers to continue to buy music products on CD and vinyl. One tactic that has worked is the music DVD. Recent figures show that music DVD sales rose by around 52 percent in both the USA and the UK in 2004, which makes DVDs the best-selling music format after CDs.

When the first DVD music videos debuted in early 1997, the new format was an instant hit as it not only offered excellent sound, but also imagery that was twice as good as it had been on VHS. Biggest sellers to date include Robbie Williams, The Beatles, Coldplay, Elvis, Oasis, and Queen, and much of the material on the DVDs is live performance, previously unreleased footage of a band or artist, artist interviews, and other "added extras."

This, of course, means that the creation and design of DVD packaging has become as exciting as that of vinyl and CD packaging. This book looks at an international collection of innovative graphic design within the area of DVD cover design and packaging, and explores both the creative inspiration behind the work (the artwork, typography, materials, printing techniques, and formats) and the practical considerations and restrictions (record company stipulations, inclusion of essential material, and budgets).

With the inherent size and dimension constraints, the DVD format challenges designers to create an interesting package that not only stands out, but also visually interprets the material inside and communicates this to the consumer. Experimentation and variations on the norm enhance the experience of the consumer by giving them something more than just simply a DVD in a plastic box, and allow the artist to reflect their creativity in a way other than through their music.

As well as products from the music industry, DVD-Art also explores work in areas such as movies and TV. Like music DVDs, this is also a booming sales area because, as well as new releases on DVD, consumers are also replacing their VHS collections by buying old TV favorites that have been rereleased on DVD. There are great examples of such work throughout the book, from some of the biggest home entertainment companies in the world, to smaller, independent releases.

The other areas of DVD production that I look at include moving-image collectives that put their work on DVD, video directors who have DVD showreels, and books and magazines that are produced in conjunction with DVDs. Projects include covers for nightclub Cream's music DVD, onedotzero's graphic and animated film events, Mochilla's live recording, and offshoot DVD packages for Lowdown and IdN magazines.

The scope that the DVD format offers, and the fact that so many different industries are using it to promote all kinds of work, has resulted in the design world beginning to show interest in DVD packaging. Its current recognition is shown by the advent of conferences and awards that focus on the subject, including Medialine's annual DVD Entertainment Conference and Showcase, the Entertainment Packaging Summit (an annual event that combines a conference with a show floor displaying packaging solutions), and the Alex Awards for excellence in entertainment packaging. The graphic design of DVD packaging is also gaining prestige as it becomes a recognized design category, with projects winning American Design Awards.

As well as the physical packaging, DVD-Art also explores the digital content of DVDs. The design of the interface and navigation systems is an art in itself, and is, in most cases, done by DVD "authors," sometimes exclusively, sometimes in conjunction with the graphic designer. It can be as creative and innovative as the packaging. Design companies, such as award-winning The Pavement, have become renowned for their unique approach to DVD production and design. There is also a trend toward including "hidden" extras on DVDs, with the consumer needing the knowledge and curiosity to "find" them, making the whole experience more exciting and adding an element of discovery and of "being in the know."

Like the CD, the DVD package is bought in-store, taken home, unwrapped, and explored by the purchaser. The more that they get from it, the more it becomes worth its cover price, and the more likely they are to buy another. This book is full of ideas on how to make DVDs worth that cover price, acting as an inspiring showcase of packages that I believe challenge the predictable "mainstream" look of DVDs. Informative and easy to read, it offers practical advice on the key considerations and requirements relating to DVD packaging and design. In addition, the designer and client interviews throughout offer an insider view on the industry. Importantly, this is the first design title that looks exclusively at DVD packaging and design—a format that will surely be around for quite some time.

Charlotte Rivers

02

"I remain convinced that extraordinary work is possible within the constraints of the format."

Sam McCay, Vice President, Creative Services, MGM Home Entertainment

Form

Introduction

As the jewel case became standard for CD packaging, the Amaray case has become the industry standard for DVD packages. Amaray cases are plastic, come with a push-button hub, literature clips, and a full sleeve for artwork. They are, without doubt, functional and practical; they are lightweight, conform to a standardized size, fit the shelves of all the major record stores, and are cost-effective. Sadly, they are also cheap and nasty.

However, thankfully, many designers are exploring other forms of packaging, using different materials, printing techniques, shapes, sizes, and so on, in an attempt to make the DVD package more appealing to consumers, and to extend their experience beyond the simple act of buying a film, music video, or other product. The tactile nature of a DVD package remains in the memory just as the artwork and imagery does, and together this gives it a unique appeal—vital when looking for standout.

This chapter explores examples of such work as the six-panel, matte board packaging created by Soap Design for Mochilla's Keepintime project. The form of the package should be a key consideration when designing a DVD cover. How will the user interact with it, and will it make them want to buy it?

Materials

"Special packaging eats into the profits.
But manufacturers must start investing
into alternative packaging."

Erwin Gorostiza, Sony Urban Design Director, Sony

Client: **Yvon Lambert**
Design: **Antoine+Manuel**
Year: **2002**
Country: **France**

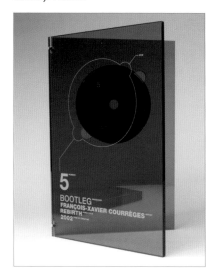

Bootleg video art series

Bootleg, which was set up in 2002 by Yvon Lambert and Olivier Belot, is devoted to the production of video art on DVD. It promotes leading and emerging video artists, and so far has produced seven DVD series for artists such as Vibeke Tandberg, Rennid Gnikam, Carlos Amorales, Jonathan Monk, and Mircea Cantor. Each series is limited to a total of 50, which are signed and numbered, so the packages had to reflect the idea of "exclusivity" and be something a bit special, luxurious, and, above all, beautiful. The packages are the size of a book, and, to make them more impressive and precious, are constructed from thick Perspex, giving them a good weight—approximately 2.4lbs (1.1kg). Helvetica Neue has been used throughout, silk-screen printed onto the gray, transparent Perspex cover, and hot-stamped in dark gray onto the slipcase. The series are only sold at the Yvon Lambert Galleries in Paris and New York, and in selected art bookstores.

Client: **C-TRL Labs Inc.**
Design: **C-TRL Labs Inc.**
Interface: **Devan Simunovich/Nika Offenbac**
Year: **2004**
Country: **USA**

C-TRL Labs demo packaging

This promotional DVD was a demo release to show corporate work, fine art, short films, and VJ material. Devan Simunovich and Nika Offenbac designed both the packaging and the interface. The style of the packaging is technical and architectural, and tries to express the feeling of "containing" the DVD. This is countered by the use of the transparent slipcase and label, which make the DVD fully visible from the outside. Some 3-D elements used in the DVD menu are also used on the casing to provide design continuity. In addition, bracket marks are built into the design to frame a business card that can be slipped under the plastic sheeting. Arial Black and Arial Narrow have been used throughout, and everything was designed in Illustrator and 3D Studio Max. The DVD case is called ThinPak Clear, and is manufactured by NEXPAK. The designers have printed a monochromatic design onto transparent paper which has then been inserted into the case. In addition, the DVD face has a complementary monochromatic design, laser-printed as needed.

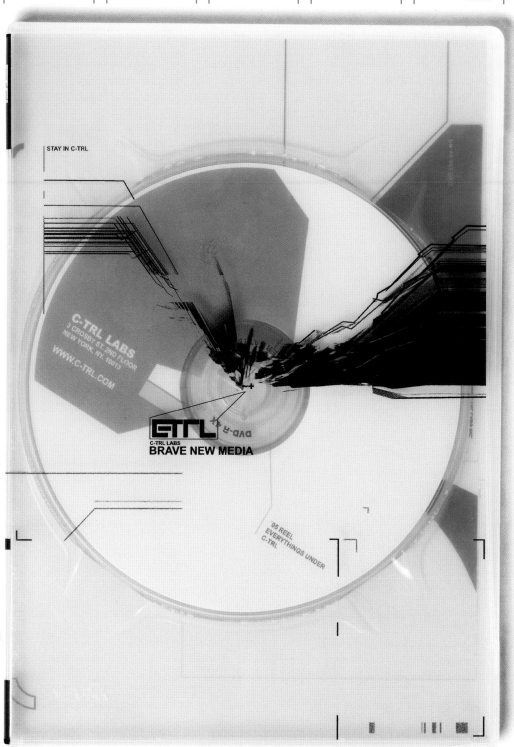

Client: **Weiden + Kennedy, Nike**
Design: **Nike/Neverstop/C505**
Year: **2002**
Country: **USA**

Nike Presto, Spirit of the Movement

In 2002, Portland-based multidisciplinary creative agency Neverstop was asked by advertising agency Weiden + Kennedy to create a package for a promotional DVD being created by Nike. The DVD contained videos by various artists, inspired by the theme "movement" and commissioned by Nike. The brief to the designers was to create something different that would make a strong impression on people and have an element of humor. Working closely with New York–based design house C505, they created the package using egg carton material. The package is completed with the inclusion of printed eggs on the disc. In addition, the DVD includes a "hidden" film by Animal Charm.

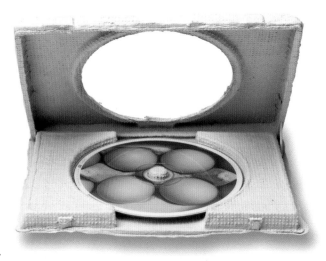

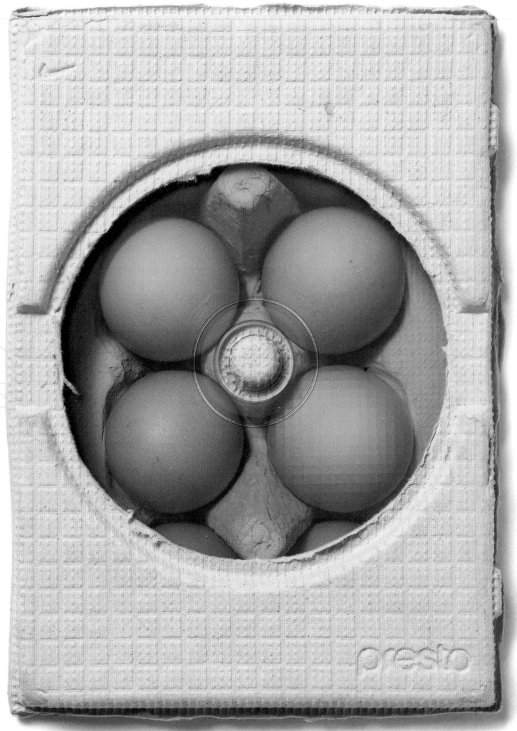

Client: **Winter & Winter**
Design: **Winter & Winter**
Year: **2003**
Country: **Germany**

Step Across the Border

<u>Step</u> <u>Across</u> <u>the</u> <u>Border</u> is a 90-minute celluloid improvisation music film with music by Fred Frith. It is held in a corrugated card package, which is used by Winter & Winter for all its releases. The imagery on the front cover has been applied using stickers, and the text has been debossed. Inside, all the relevant written information is printed on foldout matte paper sheets, adding to the natural, earthy feel that all Winter & Winter's products have.

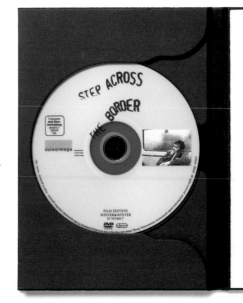

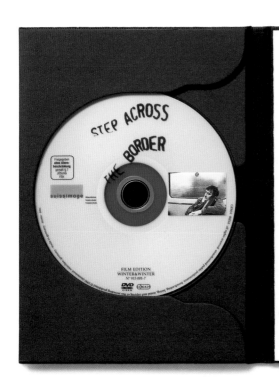

Cinematography: Oscar Salgado
Original Sound Recording: Jean Vapeur
Camera Assistance: Dieter Fahrer
Location Manager: Peter Zobel
Production Manager: Res Balzli
Film Editing: Gisela Castronari,
Vera Burnus, Nicolas Humbert,
Werner Penzel
Graphics and Animation: Lena Knilli,
Cornelia Förch
Mixing: Max Rammler
Studio Recording Engineers:
Benedykt Grodon, Rainer Carben
Shot 1988-1990 in
Tokyo, Osaka, Kyoto [Japan],
Verona [Italy],
St. Remy de Provence [France],
Leipzig [Germany],
London, Yorkshire [Great Britain],
New York City [USA],
Zurich, Bern [Switzerland]

SmartPac®19532321.1-53:
Herzog•Idex
Packaging M 97 10 405.1:
Stefan Winter
Print: Peter Postel GmbH
Scan: Typisch GmbH

Made in Germany
Winter & Winter GmbH

European Film Award 1990
· Grand Prix International «Images and Documents» Figuera da Foz 1990
· Uppsala Filmkaja
Best Documentary Film - Uppsala 1990
· Hessian Filmaward
Best Documentary Film – Germany 1990
· Innovative Cinema Prize 1991
· Golden Gate Award - Special Jury
Award - San Francisco 1991
· Chosen as one of the 100 most important movies in film-history by the critics of Cahiers du Cinema, Paris 2000

The making of this
DVD-Video
was supported by:

suissimage

The sound track [CD] of
«Step Across The Border» is
available on Fred Records

For further information
please contact:
www.cinenomad.de
www.fredfrith.com
www.rermegacorp.com
www.winterandwinter.com

Client: **EMI Music Catalogue Marketing**
Design: **Andrew Day for the Red Room
 at EMI**
Photography: **Denis O'Regan**
Interface/Menus: **Abbey Road Interactive**
Year: **2004**
Country: **UK**

Duran Duran: Sing Blue Silver

In 1984, Duran Duran toured Canada and America, on their first major tour as headliners in these countries. Over 79 days they played 51 shows in 43 cities to more than 550,000 fans. The entire tour was filmed to create this behind-the-scenes documentary, which offers some fascinating and intriguing glimpses into the fun, glamor, agony, ecstasy, and ultimate glory of three months on the road. A fantastic light blue, velour deluxe material was selected to cover the basic clamshell DVD Digibox to make it something special. Also, when embossed, velour material tends to take on a silvery sheen, making the type on the cover subtle, yet still readable. The inner tray is lined with metallic silver paper. In addition to the packaging, Day created the design and animation for the DVD, which is simple, clean, and easy to navigate. The font used is Bodoni, and is in keeping with Malcolm Garrett's original tour program artwork. Included in this DVD package is a booklet of images from the tour, as well as five glossy photo cards, each featuring a black-and-white image of the different band members.

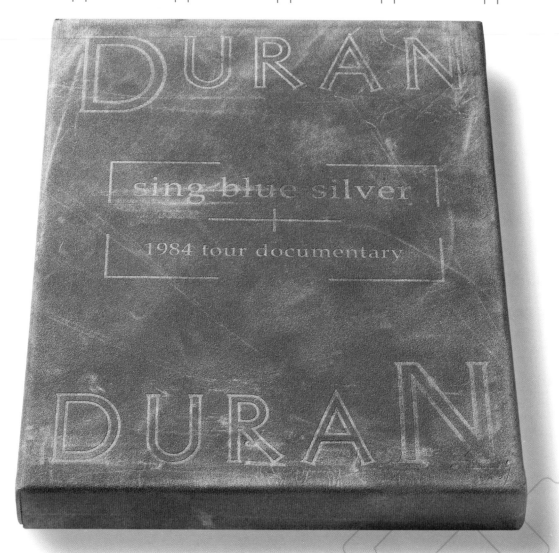

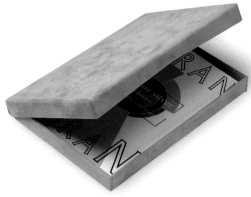

Client: **onedotzero**
Design: **Philip O'Dwyer/State Design**
Packaging Concept: **Shane Walter/
 onedotzero**
Year: **2004**
Country: **UK**

onedotzero: Motion Blur

<u>Motion Blur</u> is a book about the new graphic landscape of moving image. When published in 2004, it came with a DVD containing short graphic and animated films that had been shown at the digital film festival onedotzero. The design of this book and DVD slipcase evolved over a long period of time. Shane Walter, director of onedotzero and co-author of the book, wanted to find an unusual solution to the old problem of how to package a book and DVD for sale together. After many prototypes, it was decided that a dense foam, which was used to create a custom, die-cut slipcase, was the best solution. State Design created the onedotzero corporate fonts, which are used throughout, as well as the on-screen menus and the print elements of this package.

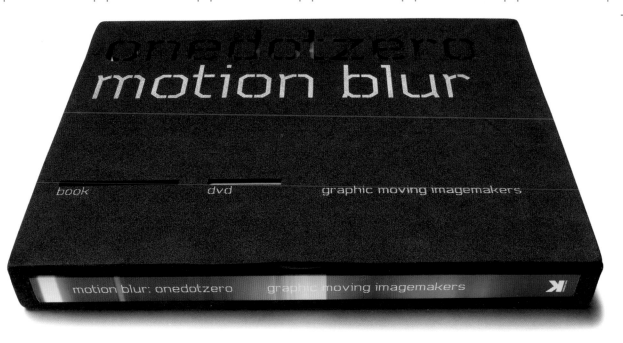

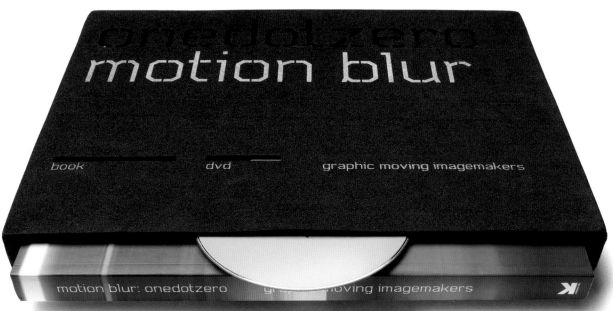

Client: **MTV**
Design: **Point Blank Inc.**
Year: **2004**
Country: **UK**

Dirty Sanchez: series 1 and 2
The brief to the designers at Point Blank Inc. when designing the packaging for <u>Dirty Sanchez</u>, series 1 was to create a brand identity that could be used on the DVD packaging, but could also be taken through to on-air and above-the-line advertising. Each package has two DVDs which are housed in a textured plastic slipcase. They contain episodes from each series as well as previously unseen footage. The clean cover design features the somewhat dark cartoon illustrations of each of the four characters in the show—Dainton, Pancho, Joycey, and Pritchard—and were created by David Bray. The illustrations capture the show's dark, comedic nature; each one was adapted for the cover of the second series. The typeface used on the covers was created especially for the project, and has also been applied to all <u>Dirty</u> <u>Sanchez</u> merchandise.

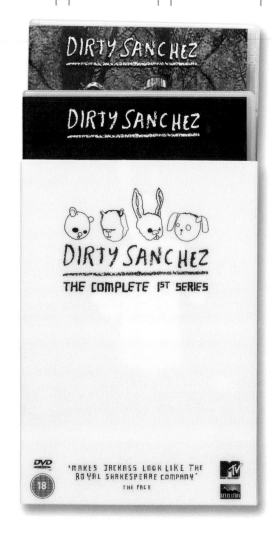

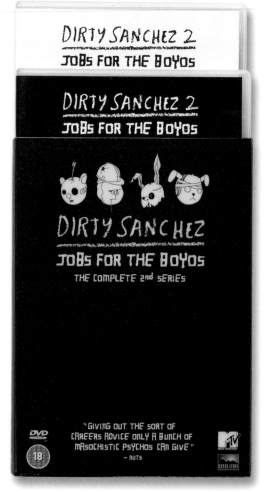

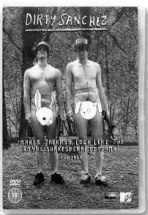

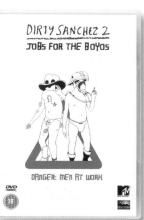

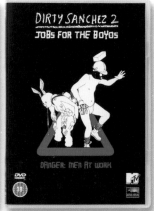

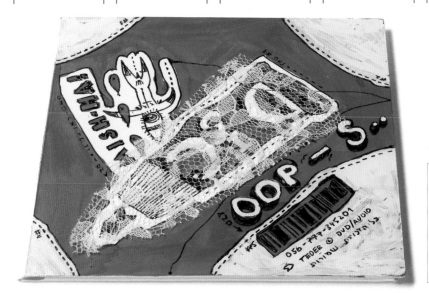

Client: **Teder Music**
Design: **Jewboy Corporation**
Fabric Work: **Moran Shin**
Year: **2005**
Country: **Israel**

Gal Tushia

This DVD contains video art and music by artist Gal Tushia. Inspired by the electronic music and analog and acoustic sounds on the DVD, the designers created this wonderful handcrafted package. The design combines many arts and crafts methods with the use of several materials, including card and lace. "This is no low-tech production," explains Jewboy Corporation. "We use printing materials and combine them with handmade work, including illustration, stamps, and sewing, so each product has its own fingerprint."

Client: **Universal Music**
Design: **Mark Debnham**
Photography: **Peter Gehrke**
Year: **2004**
Country: **UK**

The Cardigans: Live in London

The designers of the DVD were asked to create a visually distinctive package that would have in-store standout and reflect the content of the DVD. It also had to have a similar feel to the artwork of the contemporary singles and album at the time it was recorded. While the designers kept the focus on the band, they incorporated a map of London to reflect where the program was recorded. The map was printed on a laminate inlay card and inserted into a traditional Amaray DVD package. This lines up with the insert card to reveal pictures of the band.

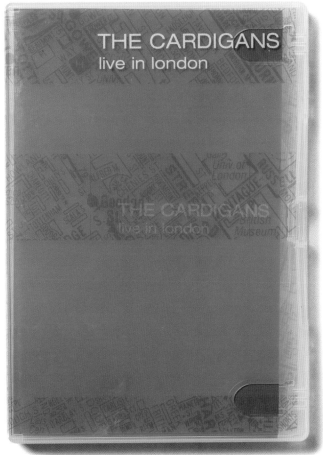

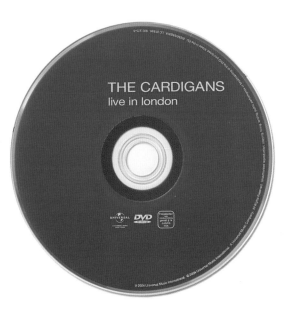

Client: **Paramount**
Design: **Paramount**
Year: **2004**
Country: **USA**

Star Trek: The Original Series

Star Trek DVD packaging is always
innovative. Designed to align with the
thematic elements of the shows, it has
always been developed in-house at
Paramount. For this collection of the
complete first, second, and third seasons
of the original show, the designers opted for
a pop design—bright colors, a plastic look,
and a playful esthetic that would be eye-
catching in-store as well as being
collectible. The result is this trio of plastic-
molded DVD packages, each of which
contains eight discs. The molded outer case
is made of hard plastic and clips shut at the
top. It also features raised titles and the Star
Trek logo. Following the release of these
DVDs, many reviewers and fans of the show
commented that the boxes reminded them
of tricorders—the multipurpose scientific
devices used by the Star Trek crew. While
not the intention of the designers, it has
been said that perhaps they developed
it subliminally.

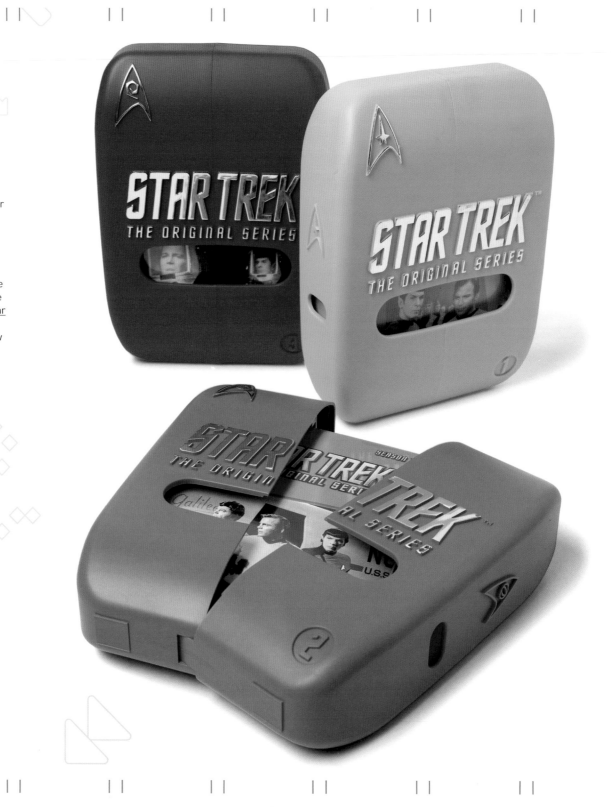

Client: **Rootziik Production**
Design: **simplefficace**
Band Logo Design: **Moogly**
Year: **2005**
Country: **France**

Hailéïnsé

This DVD is a documentary of the French reggae band Hailéïnsé. For a year they were filmed performing and recording their music. Designer Martin Lavergne was commissioned to design the package for the DVD. "It had to be simple, and in line with the visual identity that I had already done for the group," he explains. "The thing was not to fall into the classic codes of traditional reggae, so the main idea is based on the spirit of the songs—you grow up from the earth, keep strong in life, and respect nature." To convey this, Lavergne has "humanized" the letter "H," making it seem as if it is dancing and reaching for the top. In addition, he has used recycled, biodegradable cardboard for the packaging.

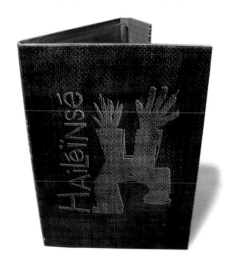

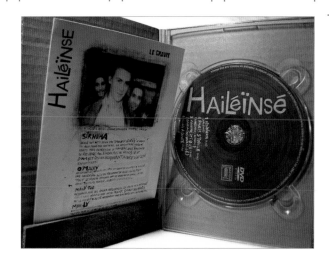

Client: **EMI**
Design: **Pao & Paws**
Year: **2005**
Country: **Taiwan**

David Tao: The Great Leap 2005

The release of this album signalled the beginning of a new phase in Asian musician David Tao's life. He wanted to express new feelings and ideas, and voice his struggles, so it features new sounds, stories, and more observations on life. The concept of the DVD design was to reflect the bright side and the dark side of the environment, and also David's perspective on life, so bright light, shadow, and a large amount of darkness have been used on the packaging. The typeface, which has been debossed, is Eurostile. In addition, a special "golden" disc has been used, together with thick cardboard, to create contrast between dark and bright.

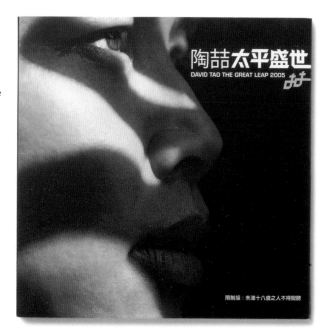

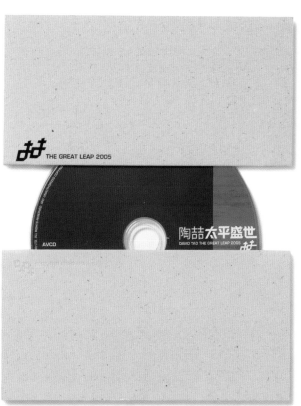

Client: **AKA Ltd**
Design: **Pandarosa**
Year: **2003**
Country: **Australia**

Håkan Lidbo: From Stockholm with Love

This CD/DVD contains an EP and three videos by Swedish musician Håkan Lidbo. The music is minimal, whereas the visuals that accompany it follow the nature of collage, similar to the visuals and artwork designed for the cover. "We wanted to create a unique, exclusive package that would stand out from normal jewel cases, but was also affordable as well as printable," explains designer Andrea Benyi. "Håkan sent his master disc in a post package covered with stamps which had beautiful animal illustrations. Since the title of the EP had 'Stockholm' in it, we decided the graphics should also have a straight correlation with the city, so scanned the stamps and created a collage with the images." In addition, the designer used Håkan's handwriting to create a typeface for the text on the package. It was a limited-edition release of only 500. The package was made from recyclable and durable cardboard, with a die-cut insertion to hold the CD/DVD, and was cheaper to produce than using a plastic jewel case.

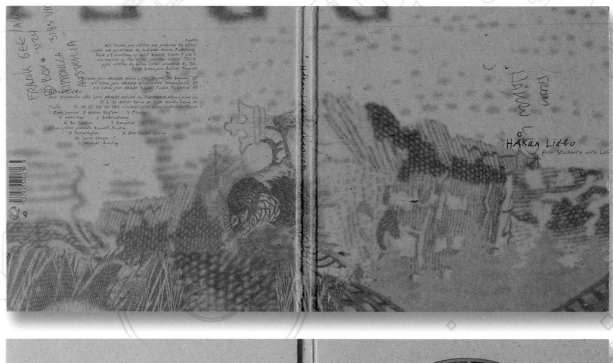

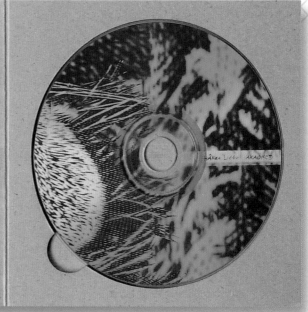

Client: **Diesel**
Design: **Lobo**
Year: **2003–2004**
Country: **Brazil**

Diesel: Lost Paradise

Diesel commissioned design group Lobo to create this unusual DVD package for the company. As the designers explain, the idea behind the package was the theme lost paradise. "We wanted to make the DVD look like something brought to the land by the sea, like a bottle with a message in it," explains Loic Dubois. "We wanted to reference pirates and shipwreck themes, a search for a treasure, or a character lost on a faraway island." The typeface used on the package was chosen by the Diesel team and the package was distributed around Europe as a promotional piece.

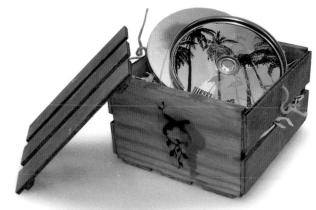

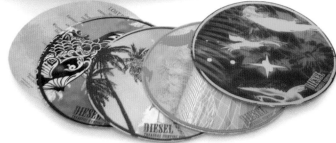

Client: **David Choong Lee**
Design: **2nd Round Productions**
Book/Package Design: **Sori Kim**
DVD Producer/Director: **Shaun Roberts**
Year: **2004**
Country: **USA**

God Made Dirt, and Dirt Don't Hurt

This postcard book and DVD set shows the artwork of artist David Choong Lee as displayed at the Levi's store in San Francisco. The disc features a video documenting the creation of the artwork, animations developed for a projected video installation, footage from the show opening, and a motion gallery of Lee's work. "Sori's decision to use the corrugated card material made such sense for the physical packaging of David's work that I felt compelled to use its texture as a base for the DVD interface. The texture reflects a lot of David's subject matter and medium; life on the street and the found art of his collages," explains Shaun Roberts. Helvetica Neue was chosen for its matter-of-fact, authoritative letter-forms. It needed to walk a fine line between emphasizing that urban, gritty texture while maintaining legibility for television screens.

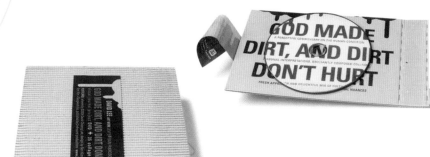

Interaction

"Let's not forget the point of these menus: to drive the user/audience to the content. Design should not compromise usability."

Erwin Gorostiza, Sony Urban Design Director, Sony

Client: **Remote**
Design: **Ted Young-Ing**
Year: **2003–2005**
Countries: **UK/USA**

Remote

Remote is a mix-tape on DVD distributed free by "street teams" in clubs and bars, at events in major cities, as well as in some art book and music stores. It's a DVD zine of film, music, and video work by artists whose work you are unlikely to see elsewhere. Remote's editors (Ted, Jason, and Kevin) simply show work that they really enjoy from the selection that people submit. "Remote is a lab for us, a place to experiment," explains Ted. "We all work for design companies, magazines, and art galleries, and wanted an avenue to explore new work and get out ideas that we couldn't through other means." The packaging had to be designed around a small budget, hence its simplicity. However, the simple package was made appealing with the use of good artwork. Issue one features experimental hand-drawn imagery; issue two uses two-spot colors on uncoated paper; issue three is more refined, using a photograph of Formula One driver Cristiano da Matta and simple typography; and issue four features a photogram by Nina Farrell together with hand-drawn type.

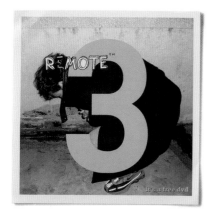

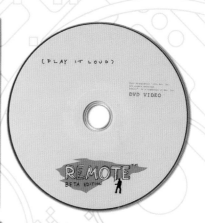

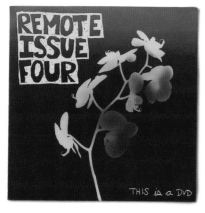

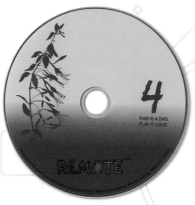

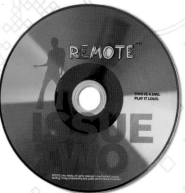

Client: **Adidas**
Design: **Pfadfinderei/Florian**
CD-ROM Production: **Pfadfinderei**
Year: **2003–2004**
Country: **Germany**

Adidas 2003 and Adidas 2004

These two DVDs were created by Pfadfinderei/Florian as follow-up promotional pieces to the Adidas shows and parties during the Bread & Butter fashion fair in Berlin, in 2003 and 2004. They contain footage from the fashion shows and the parties, as well as still photographs of the evenings. The package below, created in 2003, was designed to look like an Adidas trainer, and is opened and closed by using the paper laces. The package above, created in 2004, took its inspiration from the world soccer championship that was being held at the same time, hence the "net" packaging and soccerball-style disc. Both packages were designed to be made from one piece of paper. Designers at Pfadfinderei used a specially developed typeface for the project—Neo. The DVDs are both limited-edition releases given to "special" Adidas customers. Only 15 of each were made, all hand-cut and hand-assembled.

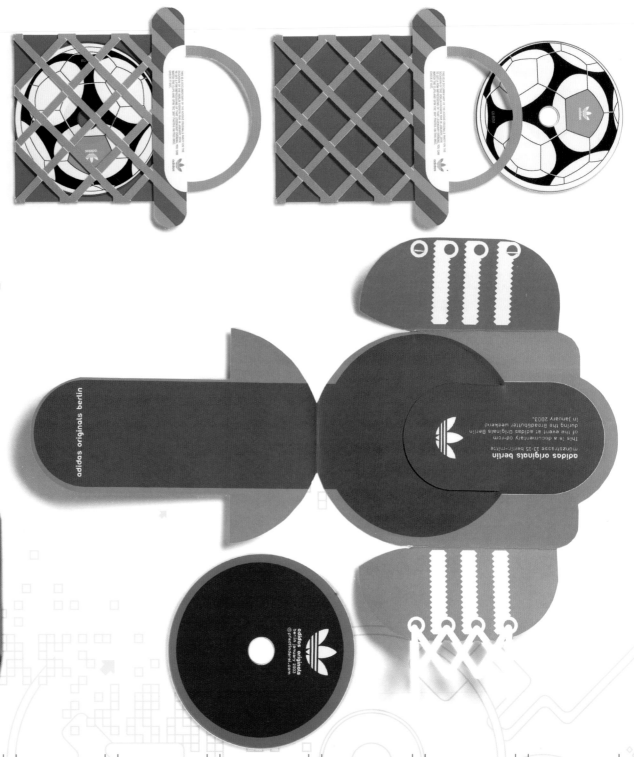

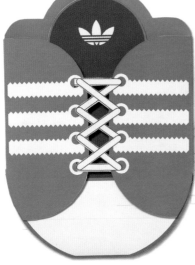

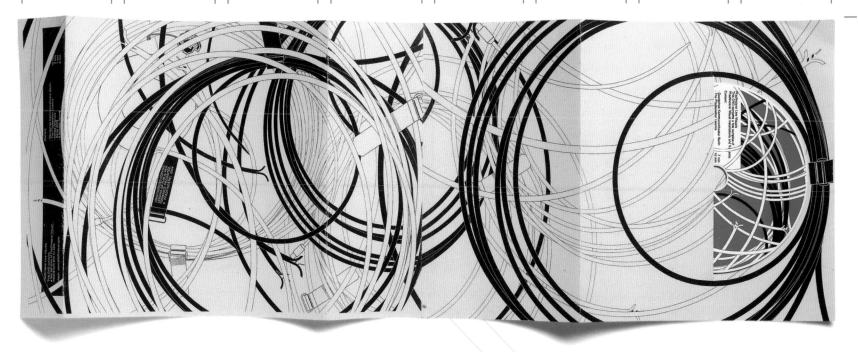

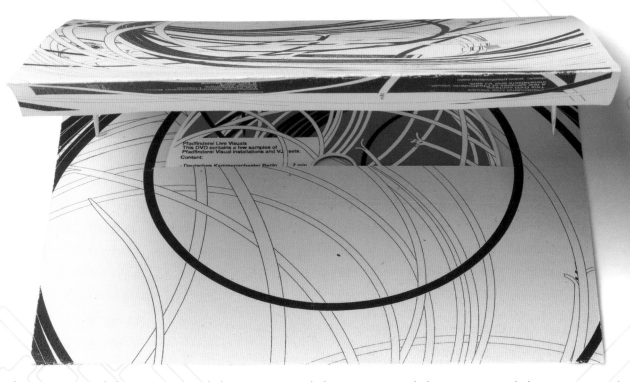

Client: **Pfadfinderei**
Design: **Pfadfinderei/Florian**
Year: **2004**
Country: **Germany**

Pfadfinderei promo 2004

This DVD contains promotional, visual material from Pfadfinderei, with music from Deutsches Kammerorchester, Apparat, and Modeselektor. The main idea behind the design was to create a low-cost, easy-to-produce, economical-to-post package that could be used as a promotional piece to distribute to Pfadfinderei customers. Printed on matte paper is a pattern based on the idea of cable, which is also carried through to the disc itself, this time in color. It is a simple, yet effective cover that is esthetically pleasing, and ticks all the boxes of the brief. A hand-made package, it was limited to a run of 50.

Client: **Fabulous Films**
Design: **Form (Paul West/Nick Hard)**
Art Direction: **Paul West**
Interface: **Dysfunction**
Year: **2003**
Country: **UK**

The Water Margin: complete series

The Water Margin is a 1970s television series best described as a "Robin Hood set more than 1,000 years ago in ancient China." Shown here is the complete series of 26 episodes, which comprises 13 DVDs housed in a card slip box. Designers Paul West and Nick Hard at Form started by producing a number of different colored portraits of the hero—Lin Chung—in a Warhol-esque way. These are used, together with enhanced TV stills, to create a different cover for each DVD. Black-and-white images were created for the DVD spines so that, together, they build up an image of all the hero outlaws featured in the series. Below them, when in the right order, is one of The Water Margin's famous sayings.

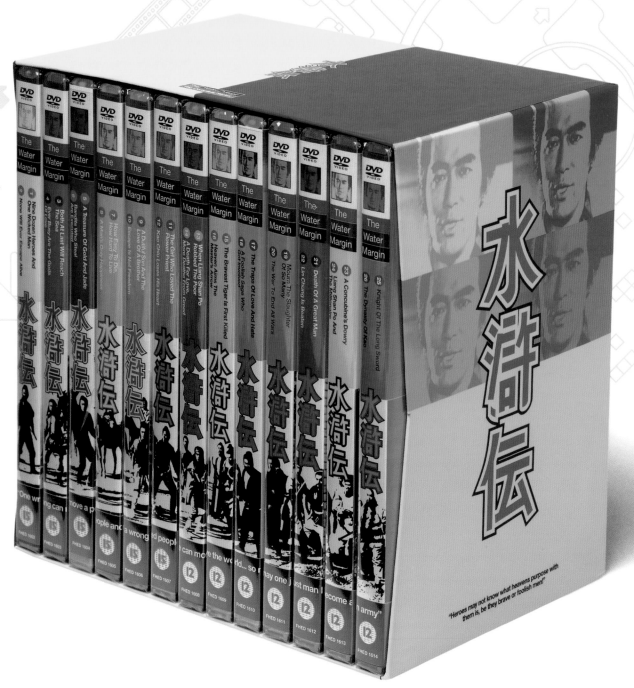

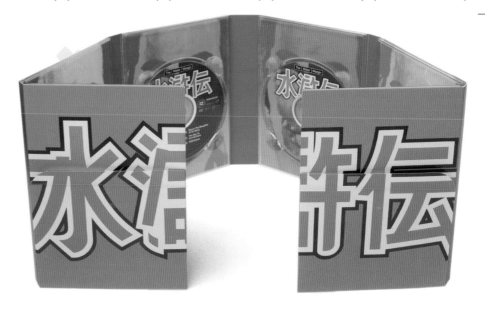

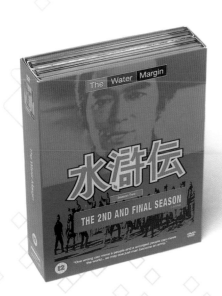

Client: **Fabulous Films**
Design: **Form (Paul West/Nick Hard)**
Art Direction: **Paul West**
Interface: **Dysfunction**
Year: **2003**
Country: **UK**

The Water Margin: series 1 and 2

Shown here are the DVD packages for the first and second series of the 1970s TV show, each of which comprises six DVDs housed in a 12-panel Digipak, complete with slipcase. Form were asked to design packaging that presented the two series in an interesting way over two boxes. The packages also had to house a poster and synopsis literature. "The main idea was to combine the images we had at our disposal with vibrant Manga colors as a way of repackaging the series to a new audience," explains designer Paul West. This was done by producing multicolored portraits of the hero in a Warhol-esque way, then applying them to the cover. The packages themselves are neat and compact. Once the slipcase is removed, the package folds out in a line to reveal the DVDs. It is both interesting and tactile, as well as practical.

Client: **Nike**
Design: **Sartoria Comunicazione**
Photographer/Interpretation: **Solve Sundsbo**
Zvezdochka Sleeve: **Richard Allan**
Zvezdochka Logotype: **Marc Newson**
Year: **2004**
Country: **Italy**

Zvezdochka

The <u>Zvezdochka</u> DVD is a documentary about the revolutionary shoe Zvezdochka, which was designed by Mark Newson and Nike designers, and was produced with Nike technology. The film explores the making of the shoe, from its inspiration to its completion. The brief for the design of the package was to keep it as clean and simple as possible, and consistent with the shoebox design. It was also important not to distract attention away from the content. The only imagery used on this limited-edition, not-for-sale package was a pattern made by repeating the name "Zvezdochka"—gray on gray—and a bright yellow strip. The typeface used is Rockwell Light. What is notable about the design of the DVD-ROM is the random interface: every time it opens, it is different.

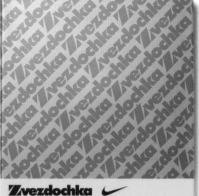

Client: **Royal Norwegian Embassy**
Design: **Non-Format**
Interface: **Hege Aaby at Sennep**
Year: **2005**
Countries: **UK/Norway**

Stærk

<u>Stærk</u> features photography, graphics, short films, and music videos from a number of Norwegian creatives. It was a promotional piece for the Royal Norwegian Embassy to publicize Norway's 2005 centenary celebrations. Stærk means strong in Norwegian, and the designers were keen for the packaging to reflect this in some way. In addition, the DVD was to be distributed with subscription copies of UK magazine <u>Creative Review</u>, so bulk and weight factors had to be taken into account. "We forewent the usual DVD packaging in favor of a brand new, custom-made wallet with a tear strip," explains Jon Forss at Non-Format. "We wanted the typographic treatment of having the title struck through with a bold line carried into the function of the packaging, and decided upon a tear strip that would rip the wallet in two once opened." It is intended for this outer wallet to then be discarded, and the inner wallet containing the DVD and content information to be kept. The interface is based on the packaging design. Everything has been designed using Serif Gothic and Helvetica. This is a great lightweight, compact, plastic-free package.

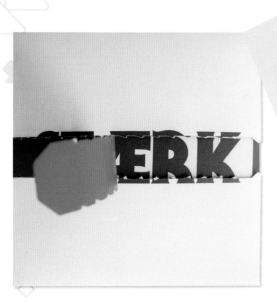

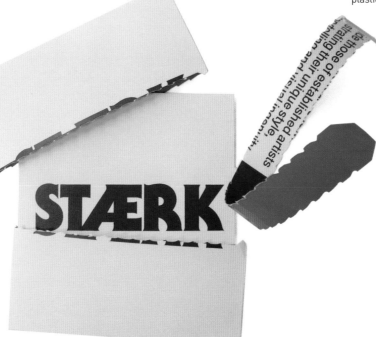

Client: **Fox Broadcasting Company**
Design: **Erbe Design**
Year: **2003**
Country: **USA**

Fox Emmy DVD mailing project

Fox Broadcasting wanted a special package created for the DVDs that would be distributed to voting Emmy members in 2003. The DVDs act as a showcase for the shows that were nominated for awards that year, so it was important that the package was sophisticated, and served as a commemorative set of DVDs. "The inspiration for the packaging was for it to be clean, simple, and elegant to reflect the special honor of an Emmy nomination," explains Maureen Erbe at Erbe Design. "A clean, typographic approach was used for the outer case to make it look sophisticated. This look was then translated to each individual package and DVD." In order to eliminate the use of a plastic, off-the-shelf look, the pieces were printed on a special heavy stock to give them substance, and to form a nice cohesive unit. The DVDs were silk-screened with the same graphic elements from the DVD covers to tie the pieces together. Garamond 3, Meta, and Gill Sans typefaces were used throughout.

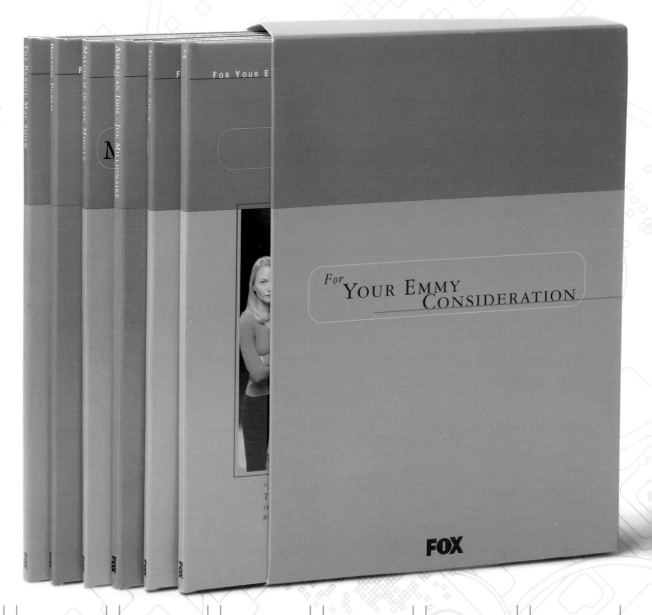

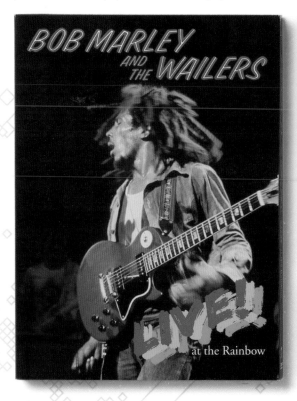

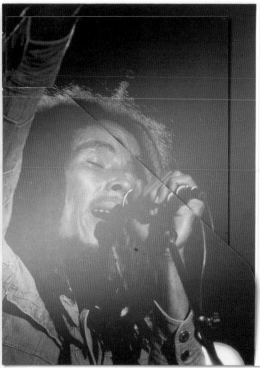

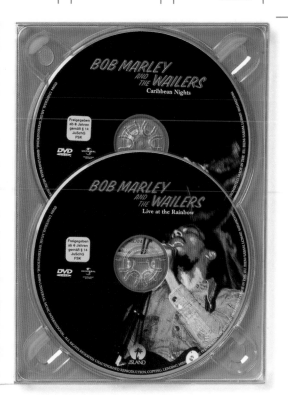

Client: **Island Records**
Design: **Universal Music**
Year: **2004**
Country: **UK**

Bob Marley and the Wailers: Live! at the Rainbow, and Caribbean Nights

This two-DVD set features a live gig and documentary of Bob Marley and the Wailers. It also features footage of Bob Marley's house. The designers at Universal Music used images of Bob Marley singing during the concert on the cover to capture the energy and vibe of the live performance. The DVDs are housed in a simple two-panel Digipak which comes with a booklet insert, again featuring Bob Marley singing. The Digipak has been housed in a slipcase, which gives it an edge over plain DVDs without increasing production costs too much. The colors of the Jamaican flag, which is so closely associated with Bob Marley, have been used to apply the "Live!" text and make it stand out.

Client: **Independiente**
Design: **Yacht Associates**
Photography: **Rick Guest**
Interface/DVD Navigation: **Abbey Road Interactive**
Year: **2004**
Country: **UK**

Embrace: Out of Nothing

This package contains one music CD and one music DVD. It was designed for UK band Embrace and the release of its album <u>Out of Nothing</u>. The DVD contains a photo gallery along with footage of the band's secret gigs, and of their performance for competition winners on a yacht in the Mediterranean. Why the CD format? "As a product, DVD boxes are usually not a very design-friendly item as they are very basic and physically cheap in construction. Unfortunately, the final product is usually a let down," explains Richard Bull, a designer at Yacht Associates. "I often wonder if the standard DVD case were actually invented as a stopgap, in so much as everyone was waiting for the next guy to give the product a bit of substance, but it just never happened."

SOMEDAY

Someday you're gonna see the way I see things.
Break out the box they keep you sealed in, Someday you'll find the real thing.
Someday you're gonna feel the isolation, 'cause no one wants you with them.
Someday I'm gonna bring you back. And you won't know how to act.
The world you think is safe is changing fast. And all who run away will run these fast.
If you turn away you can't turn back. The time has come to make waves.
And it just don't matter too much to me.
If you can't run 'cause I will carry you upon my back until you're safe
and you will feel the way I feel someday.
Someday you're gonna feel the way I'm feeling.
But all the bad you think I'm suffering won't break, it only heals me.
And it just don't matter too much to me.
If you can't run 'cause I will carry you upon my back until you're safe
and you will feel the way I feel someday.
For every stone you throw you'll carry a million more and you'll be sorry.
No one will escape who knows the way and we will all row as we reap someday.
A light is gonna shine on you and I. A light is gonna shine.
Someday you're gonna see the way I see things.
Break out the box they keep you sealed in.
Someday we're gonna bring you back.

LOOKING AS YOU ARE

I told the devil and the deep blue sea to hide.
I thought that you were after them.
I was right. But it's a picture I'll always keep in mind.
Where you say I've never been even liked for anything truly noise.
And you did it looking as you are.
Love enters and leaves you through your eyes.
You throw away the only thing that I liked.
And though they tell you things would be alright.
It never really seems that way late at night.
When you did it looking as you are.
And though I know that the world's not waiting for you are for me.
Now I know that the world you hated won't change.
'Cause you did it looking as you are.
Now you're gone I'll stand on my own.

01/ASHES 04:20
02/GRAVITY 04:29
03/SOMEDAY 05:38
04/LOOKING AS YOU ARE 04:04
05/WISH 'EM ALL AWAY 03:58
06/KEEPING 04:31
07/SPELL IT OUT 04:55
08/A GLORIOUS DAY 03:51
09/NEAR LIFE 05:46
10/OUT OF NOTHING 05:51

DVD BONUS DISC
SG#15 SECRET TOUR
SG#14 SUN SEEKER

All songs written by McNamara & McNamara except 'Out Of Nothing' and 'Near Life' written by Embrace and Martin Glover for B-Unique Music and 'Gravity' written by Chris Martin, Guy Berryman, Jon Buckland and Will Champion.

Secret Tour: Director, camera and editor - Stuart Watson at Get Shorty Productions.

Sun Seeker: Written, directed and edited by Tony Stanton. Produced by Tony Stanton and Mick Date. Cameras: Sam Spence, Sean Lamberth, Tina Mints, Larry Magee. Production Assistant in Majorca: Danielle Lacroze. Production Assistants in the UK: Charlie du Pre and Sinead Dineen. Sound by Will Jackson. Photography by Louise Helliwell. Sunseeker courtesy of Dreamseeker Charters. Transportation: John Dalby and Beaver. © 2004 Tony Stanton/An Agency Called England.

Thanks to: Wharfedale, El Cielo Bar - Majorca, Jet2.com, Transmediterranea Ferries, Gaas Moto, Tony Perrin, Carl Cox and The Foxy.

Campaign photography by Rick Guest at East Photographic. Art Direction & Design by Richard Bull for Yacht Associates.

DVD Photo Gallery: Photographed by Simon Weller. mail@simonweller.com.

DVD contents authored and designed by Abbey Road.

All tracks published by Warner Chappell Music Ltd except "Out Of Nothing" and "Near Life" published by Warner Chappell Music Ltd and B-Unique Music and 'Gravity' published by BMG Music Publishing Ltd. The copyright in this sound recording is owned by Independiente Ltd. All rights of the manufacturer and of the owner of the recorded work reserved. Unauthorised copying hiring, lending, public performance & broadcasting prohibited. ℗ 2004 Independiente Ltd. © 2004 Independiente Ltd. MCPS. www.embrace.co.uk www.independiente.co.uk

DVD Running Time Approx. 75 minutes. Sound: PCM Stereo. Aspect Ratio: 4:3. Disc Format: DVD5. Warning: The content on this DVD includes strobing effect which may affect viewers with photo-sensitive epilepsy or other such conditions. This DVD contains strong language that may cause offence. Parental guidance is recommended.

ISOM45CDX

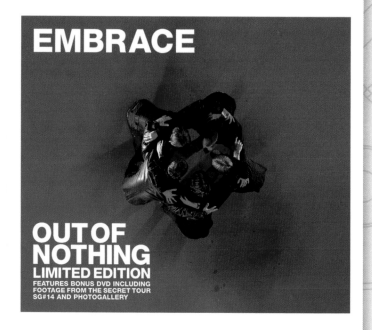

EMBRACE

OUT OF NOTHING
LIMITED EDITION
FEATURES BONUS DVD INCLUDING FOOTAGE FROM THE SECRET TOUR SG#14 AND PHOTOGALLERY

Client: **Verso**
Design: **Likovni Studio**
Year: **2004–2005**
Country: **Croatia**

Verso CD/DVD

Verso is a Croatian company working in technology and networking. Designers at Likovni Studio were asked to create a series of three DVD packages for the company to contain customized software solutions for their clients. The brief to the designers was to follow the visual identity of other Verso materials by using its color palette. The abstract design on the cover was created using elements of the Detector typeface, a font that suggests networking and connectivity. The package's format was created using die-cutting, and makes for an interesting, lightweight product that is easily deliverable by mail, and can also be used without the DVD as a greetings card.

Client: **Universal Music**
Design: **DED Associates**
Year: **2002**
Country: **UK**

The Best of Siouxsie and the Banshees

This is a double CD and DVD package for Siouxsie and the Banshees. It features a number of the band's singles, as well as remixes of their tracks, and a selection of their music videos. "Siouxsie's eyes were the inspiration for the sleeve design," explains designer Jon Daughtry at DED Associates. "The cover was meant to be as unassuming as possible, and to only hint at who it belonged to." Using a graphic representation of Siouxsie's eyes, the designers have created a simple, yet effective black-on-white illustration. The typeface used is a reworking of the Rennie Mackintosh–style font used on a previous release.

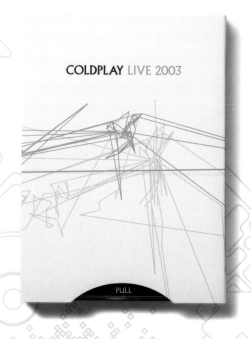

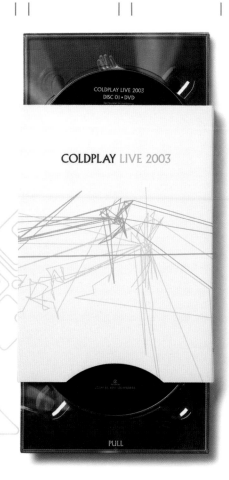

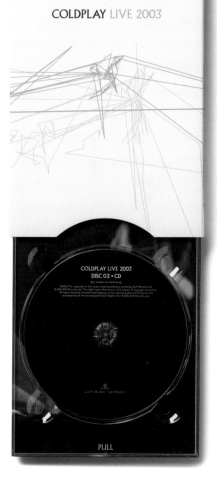

Client: **Parlophone**
Design: **Mark Tappin at Blue Source**
Year: **2003**
Country: **UK**

Coldplay Live 2003

One of the first times this DVD packaging format was used commercially was for the release of this recording of a Coldplay concert. Designed and manufactured by Burgopak, this double-tray, pull-out DVD format is a simple, yet effective piece of engineering. To access the DVDs, the user pulls on the semicircle area on the cover. When that is done, two trays appear either side of the main package. The cover image was derived from visuals that appear on the DVD, and is an interpretation of what existed as part of the on-screen elements. A matte finish and simple design make for a package that has a sense of quality. Today, the format is becoming popular amongst designers and record labels looking to use something that is slightly different.

Client: **Diesel**
Design/Art Director: **Karen Heuter at KesselsKramer**
Creative Director/Copywriter: **Dave Bell**
Strategy: **Chris Barrett, Matthijs de Jongh**
Photography: **Viviane Sassen & Martine Stig**
Year: **2004**

Diesel Dreams

The worldwide Fall/Winter 2004 campaign for fashion label Diesel, Escape with Diesel, taps into the idea that anything is possible in a world of dreams and daydreams. The campaign was created by KesselsKramer. It was composed of two elements that together worked as one campaign. The first element was the print and poster campaign which comprised 30 different images of Diesel-clad models, shown with their eyes closed, peacefully daydreaming and lost in their own world. The second was a series of films showing what those people were dreaming. Diesel worked with 30 different filmmakers, animators, artists, musicians, and illustrators from around the world,

including LoboDesign (Brazil), Honest design collective (U.S.A.), and Delaware (Japan), to create the films. Each film-maker was given a different image from the print campaign and asked to interpret that person's dream. The result is rich variety, with 30 different dreamers having 30 different dreams. The campaign was released on the Internet and as a DVD and catalog package that was distributed through Diesel stores. The DVD features simple, graphic typography and is housed in a no-frills card slipcase. The catalog features images taken from the print campaign and again, is simply and cleanly designed with subtle embossing and spot varnish on the cover.

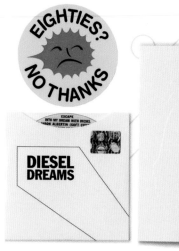

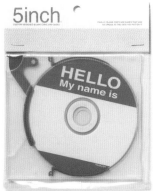
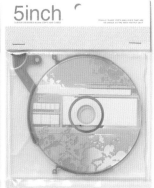
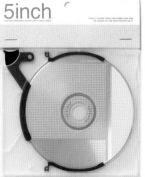
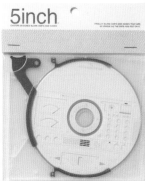

Client: **5inch.com**
Design: **Segura Inc.**
Year: **2004**
Country: **USA**

5inch.com blank DVDs

The brief to the designers at Segura Inc. for these DVDs (for its sister company 5inch.com) was to create a collectable media. "We did to blank CDs and DVDs as Swatch did to watches," explains Carlos Segura. The typefaces used on the DVDs shown here were all custom-made and screen printed. Each disc was designed to reflect the tone of a particular category, including Patter Bundle, Love Bundle, and School Bundle. Each DVD is housed in a clear plastic, trigger-pack case.

Paper Manipulation

"I have often been drawn into buying a DVD or CD that I do not want purely by the look and feel of its design and packaging."

Peter Chadwick, Creative Director, Zip Design

Client: **The Mill**
Design: **MadeThought**
Year: **2002**
Country: **UK**

The Mill, Mill Film, and Mill Lab 2002 showreels

The Mill specializes in high-end commercials and music promos. Each division produces its own showreel for prospective clients. Shown here are the 2002 showreels designed for The Mill, Mill Film, and Mill Lab. Budget constraints meant that the designers at MadeThought had to use standard, plastic, DVD cases, but they added a sense of individuality by housing them in card slipcases to create a series of DVDs that, together, form a neat visual set. The slipcase was produced in high-gloss white Chromolux, and die-cut with an elliptical shape to the left to allow the text and color of each DVD to be visible. The Mill logo was then embossed on the slipcase in the lower right-hand corner. The Mill's corporate typeface, Helvetica Neue, has been used throughout.

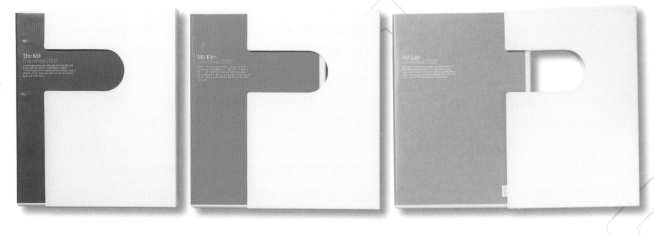

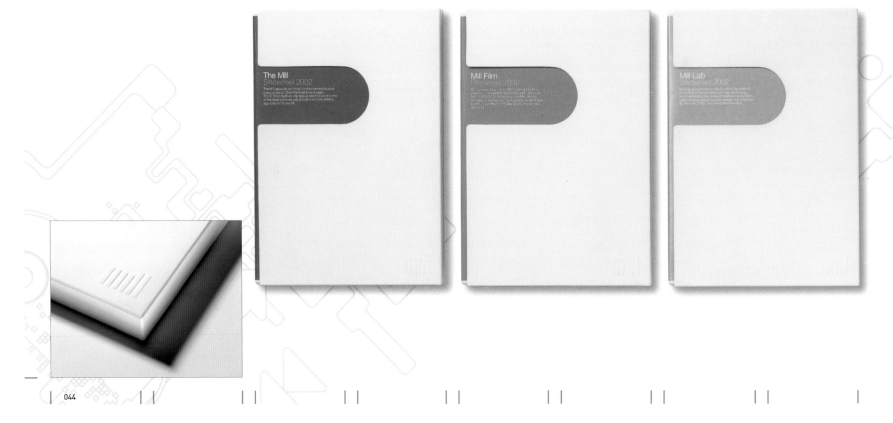

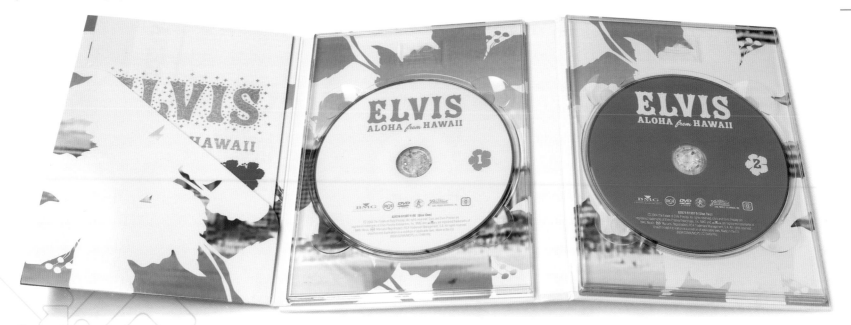

Client: **BMG/RCA**
Design: **Jennifer Garcia**
Art Direction: **Erwin Gorostiza**
Year: **2004**
Country: **USA**

Elvis: Aloha from Hawaii

This DVD is a special package containing Elvis' famous concert in Honolulu, Hawaii, in 1973. This live concert was broadcast simultaneously around the world using the then new satellite technology. The concert was seen in more than 40 countries, with an audience of more than one billion. This DVD includes not only the concert footage, but also never-before-seen outtakes and rehearsals. The brief was to continue and maintain the modern rebranding of Elvis. As the program was more than 30 years old, the design brief was to make the package "cool and contemporary," to appeal to a younger audience without alienating existing Elvis fans. The Elvis name font is redrawn, influenced by the illuminated Elvis name on the stage design of the show. The use of gold foil for the box art, and the "bling bling" stars, play off this effect. Other fonts used in the package include Zebrawood, Las Vegas Fabulous, Universe 47, and Universe 57. Hawaiian culture also played a role as seen in the hibiscus flowers on the cover, and the reverse knock-out pattern on the inside folds of the box.

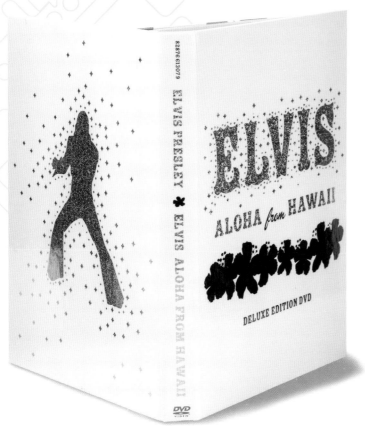

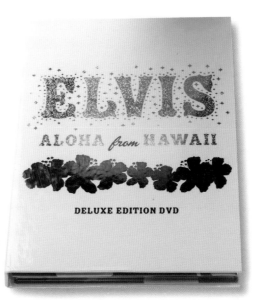

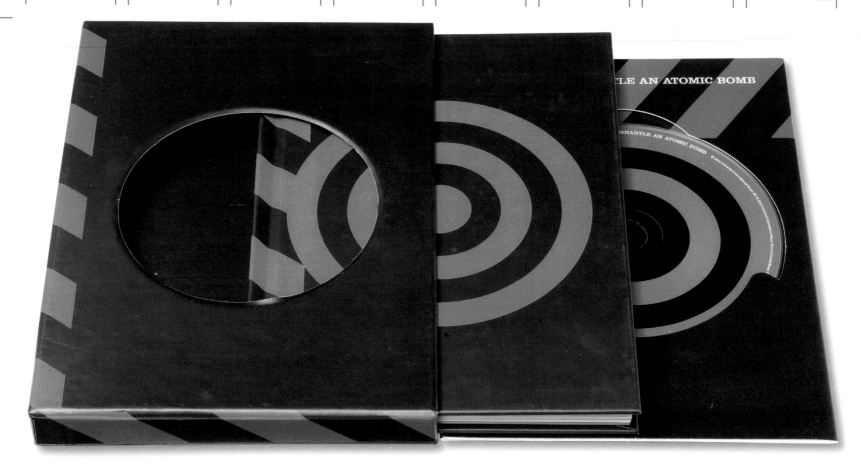

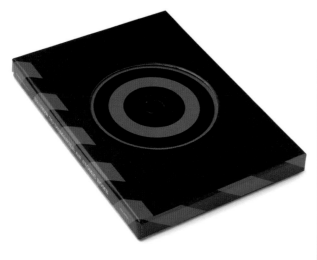

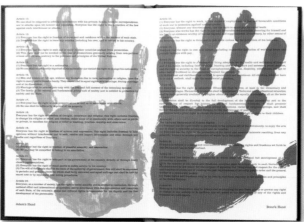

Client: **Island Records**
Design: **Four5one**
Year: **2003**
Countries: **UK/Ireland**

U2: How to Dismantle an Atomic Bomb

This was a special, limited-edition DVD, CD, and book for the launch of legendary Irish rock band U2's album <u>How to Dismantle an Atomic Bomb</u>. The package has real impact on the shelf, with its black and red color palette and die-cut outer cover that reveals the disc. Inside is the disc, housed in a separate holder, on the reverse of which is the track listing, and a hardback book that features illustrations, paintings, and photography by the members of U2. It is a stunning package that feels really solid and special—ideal for any U2 fan.

Client: **Lastrum**
Design: **Fujitajirodesign (FJD)**
Year: **2004**
Country: **Japan**

Calm presents The Cowardly Boy Ain't Stand Alone

This DVD features the music videos of Japanese band Calm. Designers at FJD have used a tree image as a way of representing the growth of the work that Calm has produced over the years, and the band's history, like the rings in a tree trunk. A hole has been die-cut on the cover so the viewer can see through to a drawing of the moon. "I hoped this would attract people to the CD when in-store," explains the designer at FJD. The traditional Japanese typeface Shineitai has been used on the cover, as well as in the booklet. All drawings were created by FJD, and the photography comes from a live Calm concert.

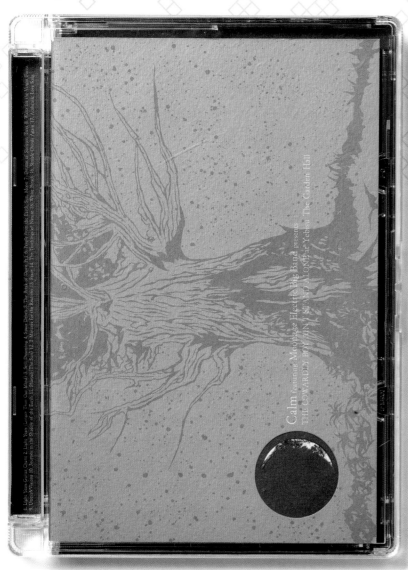

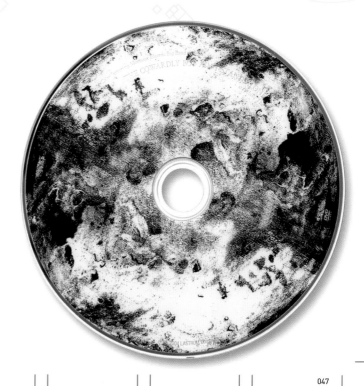

Client: **New Market/Columbia TriStar**
Design: **Blue Collar Productions/**
 Angela Stout
Year: **2001**
Country: **USA**

Memento

The word "memento" means "remember" in Latin. This film is directed by Christopher Nolan, who also wrote the screenplay, based on a short story by his brother Jonathan Nolan. The film is centered on Leonard Shelby, who has been traumatized by a blow to the head after his wife's rape and murder. He has lost his short-term memory and is out for revenge. Although he remembers life with his wife and who he is, he cannot remember anything that has happened since. The packaging is a blue file folder; the designers wanted it to feel as though you are looking into Shelby's medical records. There are four sheets of loose-leaf paper that offer hints to the DVD's structure and contents. A sheet headed "Police Department" has an image of the actual Main Menu for disk 1. A note by the designers circles the word Watch and tells people to select that to view the movie. The addition of the yellow Post-it on the inside flap was later requested by Columbia to ensure that people would be able to play the movie. A sheet of paper on the inside flap is an actual note from director Nolan to viewers hinting that the structure above was indeed a reference to the "interface" of the DVD menus. A simple, subtle embossing of the title features on the cover, and a paperclip has been added to hold the four loose sheets. This conveys the impression that someone has already been into the file.

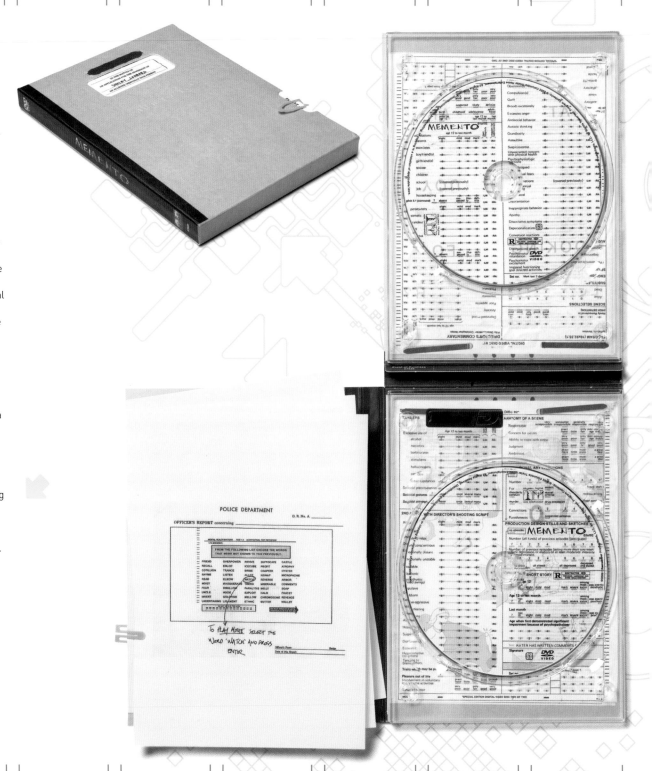

Client: **Interscope Records**
Design/Art Direction: **Kevin Reagan/Beck**
Artwork: **Marcel Dzama**
Cover Layout: **Adam Levite**
Year: **2005**
Country: **USA**

Beck: Guero

Beck's <u>Guero</u> album was the first global release of an album in surround sound. It features stunning on-screen graphics, and synced visual art, creating more than 100 different video experiences. It also features two "hidden" videos. The cover package takes the form of a hardback book, and was designed by Kevin Reagan, Adam Levite, and Beck himself. The simple, pure white cover is kept clean and minimal. The album title has been applied to the cover and spine in a simple, off-white spot varnish. In addition, a small illustration features on the back cover. Inside, a small booklet features exclusive artwork and illustration by Marcel Dzama, together with photographs of Beck. The two discs are housed in plastic tray holders on the back cover. It is a stunning package, which shows how simple, classic design can have a real impact.

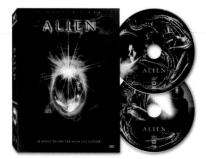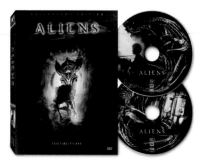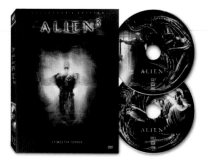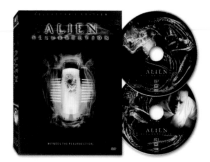

Client: **20th Century Fox Home Entertainment**
Design: **Neuron Syndicate Inc.**
Year: **2003**
Country: **USA**

Alien Quadrilogy

This is a nine-disc DVD set that includes the original releases of all four <u>Alien</u> films—<u>Alien</u>, <u>Aliens</u>, <u>Alien3</u>, and <u>Alien: Resurrection</u>—as well as the 2003 Director's cut of Alien, previously unseen footage, and commentary by director Ridley Scott and technical crew. The brief to the designers was to rebrand the entire <u>Alien</u> filmline look. "The idea of the Alien Quadrilogy package was to create a new branded identity into an artfully crafted acronym—AQ," explain designers Ryan Cramer and Sean Alatorre. This was achieved by incorporating the Alien creatures' features into the circumference of the "Q" letterform, and having the "A" represented by a glowing triangular-shaped green light emanating from the central axis of the "Q." "We were inspired to create a package that was a menacing and timeless artifact, yet paid homage to the original Alien species creator, Giger." The outer slip box and cover of this package was printed on holographic foil paper, and the "AQ" badge was sculpted and debossed.

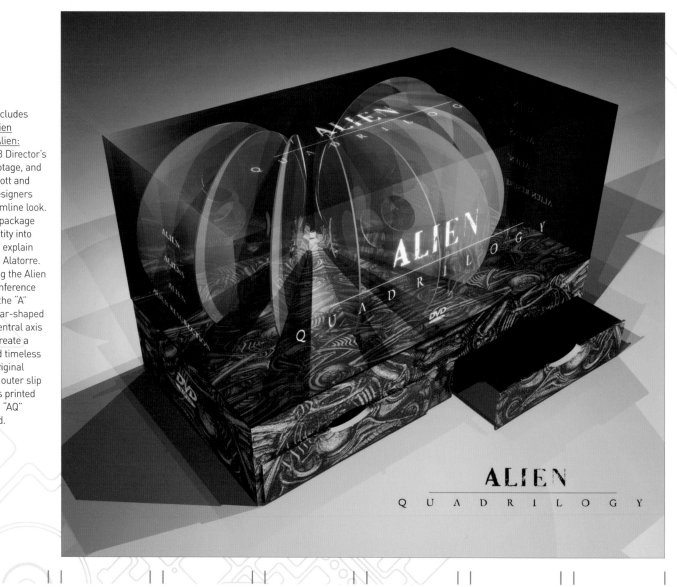

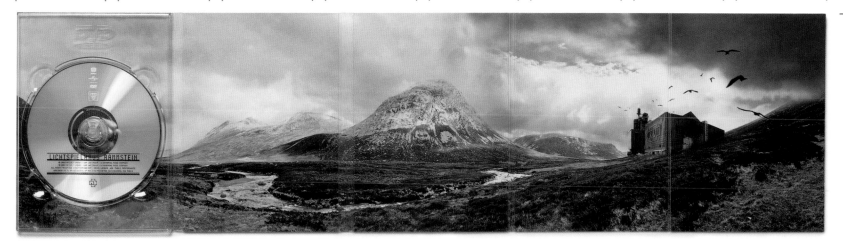

Client: **Universal Music**
Design: **Dirk Rudolph**
Year: **2003**
Country: **Germany**

Rammstein: Lichtspielhaus

This DVD package uses the 10-panel Digipak to full advantage, with a landscape image printed the length of the internal panels. The panoramic image was taken in the Scottish highlands by the cover's designer Dirk Rudolph, and was inspired by the heavy but romantic sound of the band's music. The DVD contains videos, concert highlights, and backstage "making of" footage. A UV spot varnish has been applied to the building and logo on the cover to create a more 3-D look. The band's logo is hand-drawn.

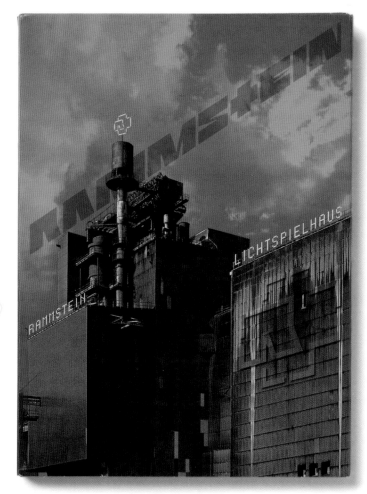

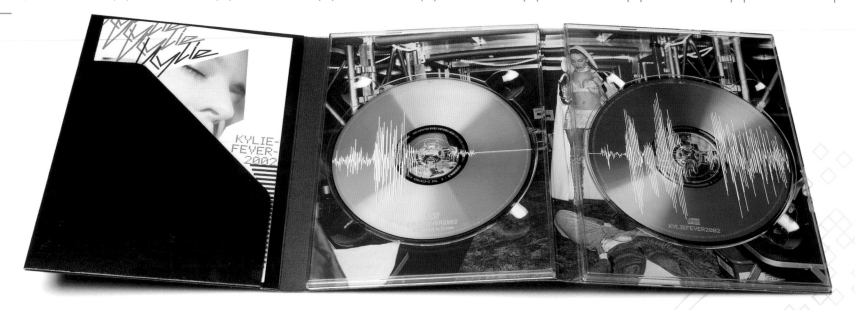

Client: **Parlophone**
Design: **Tony Hung at Adjective Noun**
Year: **2002**
Country: **UK**

Kylie–Fever–2002

This limited-edition DVD documents the live concert by pop princess Kylie Minogue in Manchester, UK, in 2002. Hung was commissioned to create the show's merchandise, which included this promotional DVD. The idea behind the work was to "mirror" the show—the costumes, visuals, and general glamor—so Hung used a high-shine slipcase cover in which to house the DVD, which also features candid documentary-style photographs of Kylie backstage.

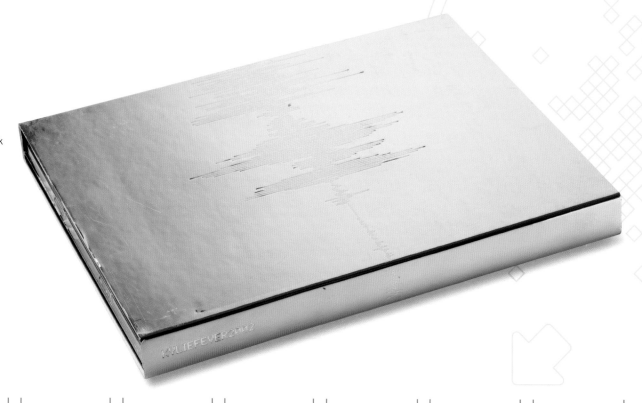

Client: **AKA Ltd**
Design: **Pandarosa**
Year: **2003**
Country: **Australia**

FNDA: Propagation

This CD/DVD contains various abstract motion pieces as well as "sound" samples by artists FNDA. The music is experimental, while the visuals are of a linear nature. "I knew we had very little budget so we gathered free, used DVD cases from various video stores in order to save some money," explains designer Andrea Benyi. "We also wanted to use more handmade esthetics against the very electronic and computer-based nature of the music on the DVD. It was inspired by the idea that both technology and human elements can combine to create a whole." Screen printing on both paper and metallic foil stickers make for the text on the cover, and give the package a handmade feel.

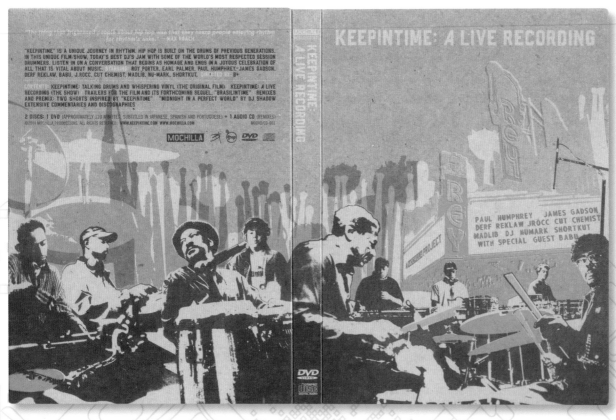

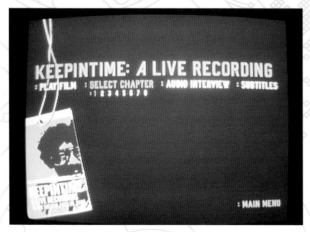

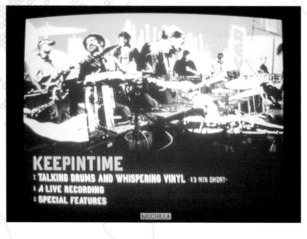

Client: **Mochilla**
Design/Art Direction: **Soap Design**
Photography: **B+**
Year: **2002**
Country: **USA**

Keepintime

Mochilla is a production company formed by photographers B+ and Eric Coleman. It functions as an umbrella company under which B+ and Coleman release their various photography, film, and music projects. This DVD, titled Keepintime, was released in 2002. It features an hour-long live concert involving a number of musicians, a short film capturing a meeting between legendary session drummers who played the beats that have had such a huge influence on hip hop music, and some of today's most acclaimed scratch/hip hop DJs. The pack contains both a DVD and an audio CD, so designer Keith Tamashiro wanted it to feel different from the typical DVD package. He started with a six-panel, Digipak format, which gave him the freedom to create a large visual package. Imagery came from the various still photos shot by the director, B+, at the live event. Tamashiro created a collage of these images, then turned them into the hi-contrast graphic images that you see here. A natural chipboard stock has been used for the package, and because of the dark color of the stock, opaque white ink was used as a base on which to overprint the color inks and to function as a spot color itself because of its legibility on the dark background. A follow-up DVD is currently in the making. Brasilintime takes the same drummers and DJs to Sao Paulo, Brazil, for a meeting and subsequent concert with Brazilian drummers and DJs.

Sam McCay, Vice President, Creative Services, MGM Home Entertainment, USA

What do you think about DVD packaging and menu design in general—what makes a good one or a bad one?
Powerful DVD packaging takes its cues from the entertainment it promotes, engaging the target audience with a personal, emotional connection that is often critical to the success of the release. Good designers think conceptually, using every available resource to communicate a title's strengths in a fresh, exciting way. Same goes for menu design.

What is the most important aspect of DVD packaging?
Differentiation. As with any retail product, if you can entice a customer to pick up a package for closer inspection, it increases the likelihood that they'll want to own it, so it pays to separate yourself from the crowd. For the US version of The Pink Panther film collection, design firm Meat and Potatoes created a case-bound "puffy vinyl" Digipak that offers a tactile experience to the consumer. It's hard to say how much the distinctive packaging contributed to its success, but this anthology has sold nearly half a million units to date, far exceeding MGM's initial projections.

Downloading music is becoming increasingly popular, and there is talk of this happening with movies. What can the film industry do to encourage people to continue to buy films on DVDs?
I have no idea. Sheer momentum will keep Hollywood's DVD revenue stream moving upward for years to come, but it seems likely to me that all things digital will eventually become accessible via some form of online home-delivery system. In the short term, must-own specialty packaging and the advent of HD [high definition] may provide greater incentive for consumers to bolster their DVD collections. Beyond that, the future of this business is anyone's guess.

What can be done to make the standard plastic jewel case cover more distinctive or innovative?
The standard Amaray-style DVD jacket is arguably no more restrictive than the much-maligned CD jewel case, yet we see far less design innovation in video packaging than exists in music. There are umpteen reasons for this, but I remain convinced that extraordinary work is possible within the constraints of the format. It really comes down to the vision, skill, and imagination of the brand marketing and creative teams.

If there was no limit to the budget, how would you design a DVD cover?
I was offered such an opportunity a few years ago. My team was assigned to develop ultra-deluxe packaging to house all 20 James Bond films in an exclusive limited-edition called The Bond Elite Collection. Our goal was to generate media publicity and help boost sales of the standard-issue Bond catalog, so it had to be not just collectible, but newsworthy. Creative agency Neuron Syndicate presented several outstanding comps. MGM selected one that featured a large circular gold aluminum base with multiple fold-out trays and drawers for the discs and bonus material, including an oversized hardbound book. The approved design required intricate machine tooling, so the manufacturing would have cost several hundred dollars per unit. The project was killed in the planning stage, but I still refer to this assignment as a shining example of what can be done when the sky's the limit.

What is your all-time favorite DVD and why?
I would be hard-pressed to name a favorite per se. Although I can appreciate a DVD's bells and whistles from a professional stand-point, more often than not it's the film itself that appeals to me.

Todd Gallopo, Creative Director/Chief Executive Officer, Meat and Potatoes, Inc., USA

When designing a DVD cover, what inspires you?
Inspiration generally comes from the film or DVD content, but budget and a creative brief from the client initially establishes our design boundaries. Since 95 percent of the DVD packaging we create involves a format change from the original incarnation—film—we are redesigning from either the original key art or set photography from archives. Anything outside those two parameters we add to the mix ourselves. We've found it important to bring something new to the design of every DVD package, rather than just shuffle around existing imagery. Typography is one of the first places we look. It plays a big role in how we design or redesign film titles for DVD.

How does it compare with CD album cover design?
When designing an album package, it's usually a clean slate. The artist or band has a body of music they have just completed. There's always something that has inspired them in their music, but eight times out of ten they have no idea how to pull from that same inspiration to create a strong, meaningful image to represent themselves and their music. So, as designers, our inspiration is derived from the music itself. And, of course, from a few opinions of marketing directors. Since it's an "artist-to-artist" working relationship, the work tends to feel more personal than that of designing DVD packaging.

How much of a role do you think the designer plays as a marketer in the retail environment?
The designer has an important role when it comes to marketing. They are the creator of the materials used to market the product. If the key points and features of the product are not communicated clearly to the consumer at first glance, then a valuable opportunity to sell to a consumer is missed. This applies to the DVD cover as well as all in-store materials used to promote the product.

Downloading music is becoming increasingly popular and there is talk of this happening with movies. What can designers, or others in the music industry, do to encourage people to continue buying CDs? Do you think that including DVDs helps?
There's no question that downloading music has changed the music industry forever. There are many reports of it doing harm to the industry, though new reports show that it is helpful to the industry, that downloading music is resulting in increased CD sales. It's a constant "he said, she said" argument. Regardless of which side of the fence your opinion resides, I would have to say that I have never seen so much special packaging in the music industry before now. The record labels are looking to find new ways to add more value to the product they sell, and designers are the professionals they turn to for creativity. Our company is fortunate to work with one of the largest printers in the entertainment industry, Ivy Hill (a Cinram company). Our synergistic relationship with Ivy Hill exposes us to new printing techniques, materials, and substrates. This knowledge allows us, as designers, to offer a client innovative ways to create

package designs that utilize the most up-to-date processes the printing industry has to offer. This knowledge of printing possibilities has given us an edge over our competition, positioning Meat and Potatoes as a leader in special package design within the entertainment industry. The majority of our DVD projects contain special packaging. As the home entertainment industry grows, and the consumer desire to download movies follows, it would be wise for DVD packaging to follow the example of the CD packaging world. I have always believed that a physical package has more value than a cluster of 1s and 0s on a hard drive.

In the event that films do become downloadable, what do you think designers could do to encourage people to continue buying films on DVD?
Special packaging would be the best way to save the physical DVD from dissolving into the downloadable world. Believe it or not, consumers love special packaging. They know when they're holding something special and precious, and the "I have to have it" instinct kicks in. These days designers need to look beyond their talent for design; they need to arm themselves with the knowledge of the possibilities of manufacturing the product, not just guess at what can be printed. They must create responsible design that does not give a client "sticker shock" when they find out a design they love can't be printed due to budget restrictions. I have heard the horror stories so many times, from clients who call us because they've been misdirected by designers.

Generally, DVDs remain packaged in variations of the standard Amaray package. What can be done to make these packages more distinctive or innovative?
Paper. I see the Amaray cover as an obstacle that we need to get beyond. The possibilities for those packages are, well, none. The actual printed material is inserted behind plastic. There's no tactile feel to the product. Printing on paper provides designers with endless creative solutions to packaging, from the folding of a package, to the inks used, to die cutting or embossing. The list goes on. Best of all, paper is easier to recycle, so "mother earth" will like it too.

If there were no limit to the budget, how would you design a DVD cover?
Well, that really depends on the project and what we needed to communicate to the consumer. But in the past we've designed DVD covers that utilize everything from pink fur (The Anna Nicole Show) to real diamonds (007: Die Another Day), to a solid block of acrylic (The Ultimate Matrix Collection). Of course, none of those were ever made. If I had to pull from the farthest corners of my mind ... let's say I was designing a DVD set for the 1998 12-episode miniseries From The Earth To The Moon, I would house the discs in a box carved from moon rock, mined by NASA, brought back to earth in a replica of the Apollo spacecraft. There would be a limited edition of 1,000, each one signed by Neil Armstrong. How's that for expensive?

03

"First and foremost it is the content of
the product that sells the DVD."

Peter Chadwick, Creative Director, Zip Design

Content

Introduction

As with a music CD or a book cover, the nature of the DVD package means that the majority of the artwork is hidden inside; in the booklet, in a poster, on stickers, and so on. As a result, the impact that the DVD cover has when seen in-store really matters. Creative and original use of imagery and typography, that not only reflects the content of the DVD but also catches the consumers' attention, makes for a memorable and iconic cover. However, as Peter Chadwick at Zip Design says "First and foremost it is the content of the product that sells the DVD. A good or interesting DVD with a bad cover will not harm the sales of that DVD."

Of course, while this is true, what a good cover and packaging design can do is add to the consumer experience when buying a DVD, whether that be through the use of striking typefaces and colors, or the inclusion of behind-the-scenes photographs and previously unpublished images. When researching examples for this chapter, I looked for work which did exactly that—added something to the whole buying experience, and complemented the digital content of the DVD itself through the clever use of imagery and typography.

When it comes to film DVDs, often the cover imagery is directly associated with the film itself and already has iconic status within the consumers' consciousness. The area of music and moving image DVD design tends to allow for more creative and abstract ideas to be explored within the artwork, for example the onedotzero series shown on page 78.

Typography also plays a role. As with music CDs, much of the text on a DVD cover is there because the client has requested it, but the designer can choose the typographical layout of that text to make it more interesting and creative.

As with music CDs, consumers take home a DVD package, unwrap it, and explore it—first the physical material (the text and imagery in the booklet), then the digital material (the DVD itself). It is therefore extremely important that the DVD package is a reflection of, and something of an introduction to, the digital content of the DVD it houses.

"I think there is a lot of scope to push the existing packaging a lot further with the use of print."

Peter Chadwick, Creative Director, Zip Design

Artwork

Client: **Cream**
Design: **Zip Design**
Art Direction: **David Bowden**
Illustration: **James Taylor**
Interface: **Pink Pigeon**
Year: **2004**
Country: **UK**

Cream: The DVD

One of the most popular super-clubs of the 1990s, Cream, originally of Liverpool, UK, has become a highly successful international club brand. In 2004, Cream created the brand's first DVD, and Zip Design was commissioned to create the packaging for it. The DVD combines highlights from Creamfields (one of the most popular music festivals in the UK), together with "exclusive" backstage footage, and features some of the world's best DJs playing 15 of the summer's biggest dance tracks. For the package itself, Zip Design took inspiration from the Creamfields experience, using a specially commissioned illustration by James Taylor to evoke memories in the minds of festival-goers of the day, and summery colors to reflect the fun-loving summer atmosphere of the event.

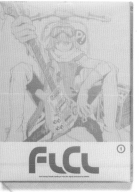
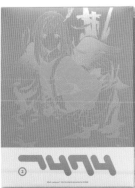
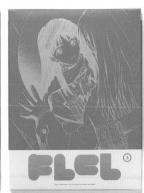

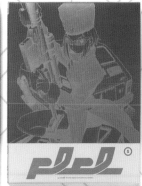
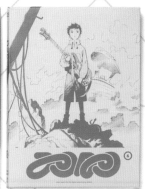

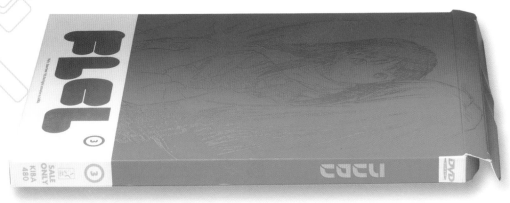
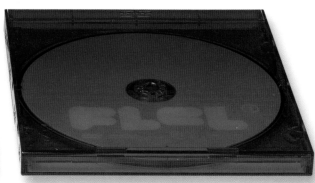

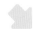

Client: **GAINAX**
Design: **Masashi Ichifuru at TGB Design**
Illustration: **Yoshiyuki Sadamoto**
Year: **2001**
Country: **Japan**

FLCL 1–6

FLCL is an original Japanese video animation that was made and produced by GAINAX and Production IG in Japan in 2000. Designer Masashi Ichifuru created this set of covers for the series, which comprised six DVDs. Using an envelope-style matte card package, Ichifuru has kept the design simple, yet effective. Illustrations by Yoshiyuki Sadamoto, who created the FLCL character, have been used, and colors have been changed with each release. The result is a series of DVDs that work well together visually.

The FLCL animation is quite different from typical Japanese animation, so Ichifuru wanted to design a more unusual package, hence the use of the envelope-style cover, and the simple, clear, one-color disc holders inside. Dax typeface has been used throughout, and printing was done using three types of DIC color instead of CMYK.

Client: **Sanctuary**
Design: **Stuart Crouch at Peacock Design**
Codesigner: **Robert Wallis**
Interface/Menus: **Mirage Productions,
	Los Angeles**
Year: **2002**
Country: **UK**

Iron Maiden: Rock in Rio

This package for UK heavy-metal band Iron Maiden contains two discs. The first is of a live Iron Maiden concert filmed as part of the Rock In Rio festival to a sellout 250,000 crowd. The second contains several special features, including interviews with the band, a day-in-the-life documentary, and 50 exclusive photos from Iron Maiden's South American tour. The DVD packaging was created by Peacock Design, who had designed Iron Maiden's <u>Rock</u> <u>In</u> <u>Rio</u> album. The brief was simply to design the DVD to go with the album. The stage set of this Iron Maiden concert was unique, with a simple oval shape. The designers wanted something to show off what was one of the biggest shows on earth. They came up with the pop-up crowd idea to reflect that, and add something more to the standard format, creating something of a miniature concert within the DVD package. They also printed crowd images onto the DVD itself.

Client: **Dalbin: label for visual music**
Design: **Pfadfinderei/Martin**
Music: **Modeselektor (Bpitch Control)**
Video: **Pfadfinderei**
Year: **2004**
Country: **Germany**

Labland

Labland brings together a series of live club visuals and music on one DVD. Created and designed by Pfadfinderei, the DVD contains nine tracks, and a bonus section with two extra tracks. An accompanying map uses the names of all the DVD's contributors as its cities, rivers, and mountains. The enclosed booklet contains stills from the DVD, and everything is housed in the more favored alternative to the Amaray case, the DVD jewel box. Pfadfinderei used its own typeface, Braten, designed by Martin Aleith, for the DVD interface. It is a simple face, ideal for the easy-to-use menu.

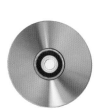

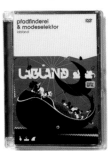

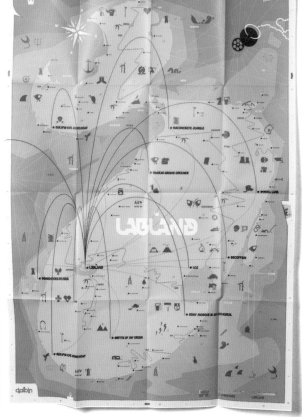

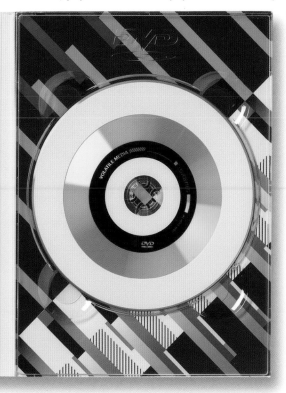

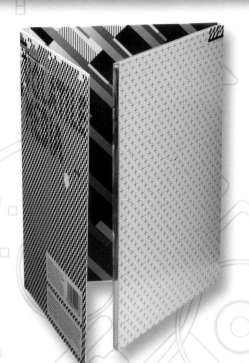

Client: **Lovebytes**
Design: **Matt Pyke** at **The Designers Republic**
Year: **2002**
Country: **UK**

Volatile Media

This DVD contains digital art software and films commissioned by the Lovebytes Digital Arts Festival. The concept behind the packaging and interface design, which were created by Matt Pyke (now at Universal Everything), was to create a feeling of uneasiness through optical illusions and glitches. Inspired by TV test cards, optical illusions, technical glitches, and the color clash of TV screens, Pyke wanted to make the design as engaging and interactive as possible, and create a multifaceted package with hidden visual surprises. Housed in a six-panel Digipak, Helvetica has been used throughout for clarity and neutrality. The result is a striking cover, inside which is provided an interesting visual journey.

Client: **Men on the Moon/XXXLutz**
Design: **DWTC Balgavy**
Year: **2004**
Country: **Austria**

XXXLutz DVD

This DVD pays tribute to the advertising spots of Austria's largest middle-class furniture mart, XXXLutz, and the Putz Family that has featured in its 62 advertising spots since 1999. In Austria, this "family" is quite famous now, having featured in so many amusing, and sometimes wicked, mini-stories. Over the years the family has found itself in all manner of places, including outer space, parliament, and musicals. The ads' creators always pay attention to current events when creating the spots. The idea for the cover was that it should be a bit "cheap and tacky," but still quality fun, with a hint of irony. The wallpaper and pictures are made to look old-fashioned, and the font is handwritten to underscore the out-of-time look. The whole DVD reflects the tongue-in-cheek humor of the ads. On the DVD everything is hidden because the menu names only show up if you scroll over the objects in the room (some viewers may not find everything). The DVD was distributed as a complementary gift to all members of the XXXLutz store buyers' club.

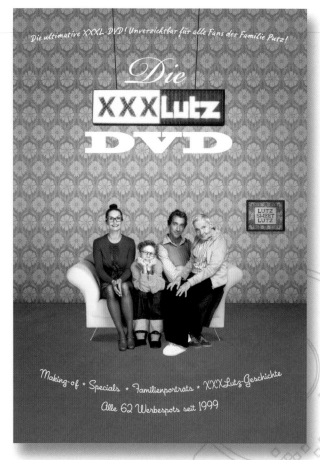

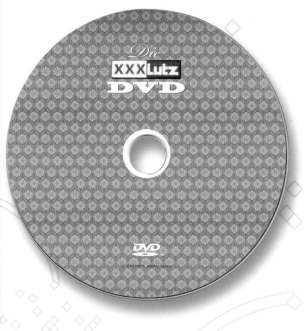

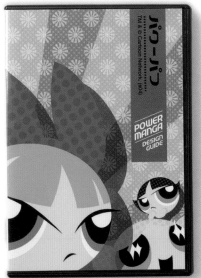

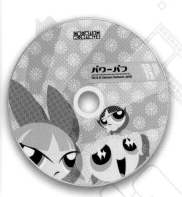

Client: **Cartoon Network**
Design: **Craftyfish**
Year: **2004**
Country: **UK**

Power Manga design guide

Designer Stewart Lucking at Craftyfish created this DVD package for the Cartoon Network. It is a style guide to be used by designers producing PowerPuff Girl–licensed apparel, furnishings, and stationery items throughout Europe and Asia, and contains Vector artwork and patterns that they can work from. The design of the DVD was driven by the elements included on the disc, these being Manga-inspired phrases, patterns, and icons. The imagery on the cover is derived from a Cartoon Network style guide, that contains character poses and phrases of the PowerPuff Girl brand. The visual element on the cover was very important as it had to ignite the receiving designers' passion to use the enclosed artwork. It also had to be easily accessible and high-impact, hence the choice of bold imagery on the cover, as well as a foldout poster that shows the contents of the DVD. The typefaces used are Technopolish and Quick Express.

Client: **The Prodigy (XL recordings)**
Design: **SafePlace**
Year: **2002**
Country: **UK**

Prodigy: Baby's Got a Temper

This DVD features the Baby's Got a Temper video and a "making of" video for UK band The Prodigy. This was shot in an old power station near Prague in the Czech Republic. The brief to the designers at SafePlace was to create a package and cover that was loud, bold, and aggressive, and that reflected the music of The Prodigy. The initial idea for the cover came from hearing part of the track, which had the sound of a creepy laughing policeman doll. Designer Jimmy Turrell wanted to give the artwork a sinister, malevolent feel, so the policeman seemed perfect. To create the cover he photographed a laughing policeman, and faxed the logo to give it a distressed feel. The title, a hand-rendered chop-up of the typefaces Platelet and Citizen, has been applied using acetate. The policeman was cut straight from the photograph. A standard gatefold-panel Digipak was chosen as the packaging, but with a matte finish, which gives the DVD a more earthy feel.

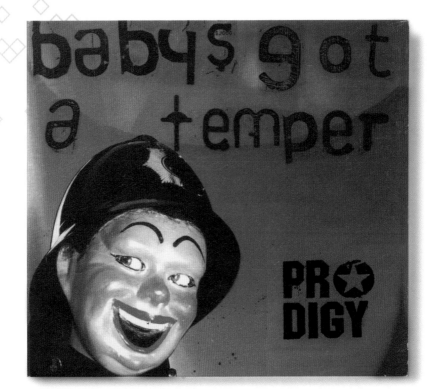

Client: **Telecine Editions**
Design/DVD Authoring: **Brett Kashmere**
Cover Insert Design: **Robert Daniel Pytlyk**
Year: **2005**
Country: **Canada**

Industrie: Oeuvres récentes de Richard Kerr

Industry: Recent works by Richard Kerr contains two hours of audiovisual material by various artists, including Richard Kerr, Gerstyn Hayward, Brett Kashmere, Michael Rollo, and Astria Suparak. The heavily textured packaging is really unusual in that the three variations of the DVD have individually handcrafted and painted covers by Rob Pytlyk. Each cover took approximately 40 minutes to produce. Production was limited to 500 signed and numbered copies. A number of different printing techniques were employed: crackle paint was used on the covers, linocut block print was used to apply the base image, a rubber stamp was used to apply the text in the inner cover, and a printed sticker was used to apply text to the back cover. Brett Kashmere created the menus using images from Richard Kerr's slide show, Demimonde, which shows recycled and manipulated strips from 35mm Hollywood film trailers.

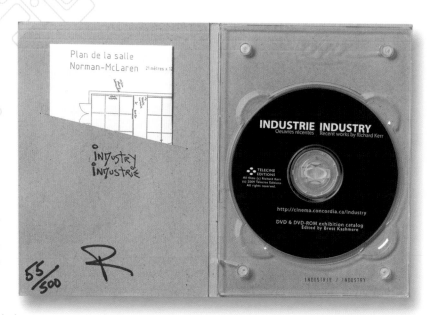

Client: **SafePlace**
Design: **SafePlace**
Photographer: **Larry Dunstan**
Interface: **SafePlace/Splitframe**
Year: **2005**
Country: **UK**

SafePlace promotional DVD

SafePlace's clients include Nike, UK band The Prodigy, and Channel 4. This promotional DVD contains a showreel of the company's animation and print work. In a self-initiated brief, the designers decided to create a package that was iconic and bold, yet had a feminine edge to it. Firstly, photographer Larry Dunstan was commissioned to photograph a model, then the designers added the locusts and bird imagery around her. A matte Digipak was chosen as the packaging format to give the DVD a solid, tactile feel.

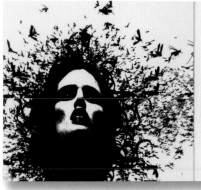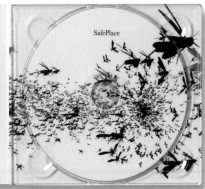

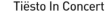

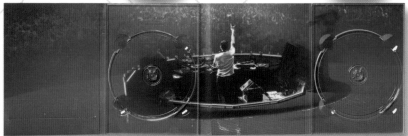

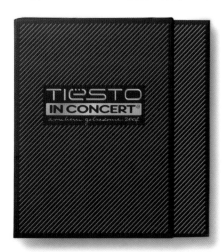

Client: **Black Hole Recordings/ID&T Music**
Design: **Locografix**
Year: **2004**
Country: **The Netherlands**

Tiësto In Concert

Tiësto, a popular DJ in the dance music world, has twice been crowned the world's No. 1 DJ by DJ magazine. In 2004 he performed a series of shows in the Netherlands and Belgium to more than 70,000 fans. Tiësto In Concert captures these dance events from all corners of the stadium and also has extra features to explore. The theme of the shows was "magic," and the brief to the packaging designers was to create something that communicated this theme.

At each step in opening the DVD box (there are three), full-page photographs of the concert are revealed, which help to emphasize the size of the event. Once fully opened, with the discs and booklet removed, a wide-angle image of the stage and crowd appears. The eight-panel Digipak is housed in a slipcase, and all elements have a matte finish, giving the package a soft, tactile feel.

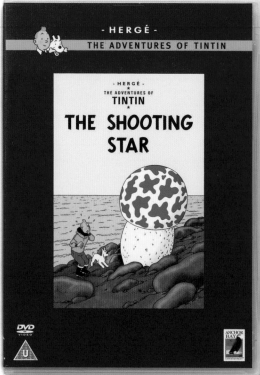

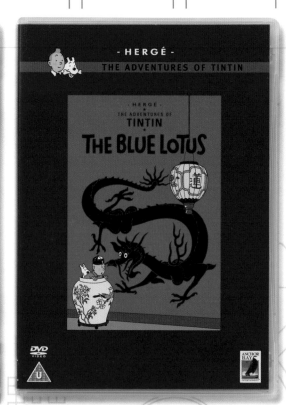

Client: **Anchor Bay Entertainment UK Ltd**
Design: **Moulinsart**
Year: **2004**
Country: **UK**

The Adventures of Tintin

Created by the Belgian writer and illustrator Georges Rémi, otherwise known as Hergé, Tintin and his companion Snowy first appeared in 1929 in Le Petit Vingtieme, a children's supplement to Brussels-based newspaper Le Vingtieme Siecle. The following year the pair appeared in their first comic book, Tintin, Reporter, In the Land of the Soviets, and have since appeared in more than 120 million books, published in 45 languages, and in 50 countries. In 1992, Tintin the animated series was produced. These have since been released on DVD.

Shown here is the box set which was designed by Moulinsart. The brief was to make the DVDs look like the slim Tintin books, and replicate how they would look in a bookcase. The designers used slimpack cases, produced by Nexpak in Holland, and housed them in a rigid slipcase box made from white, lined chipboard. This was wrapped in an artworked matte art paper, with a spot gloss finish on Tintin and Snowy. It makes for a simple, neat package that has a real sense of quality and is clearly reminiscent of the original series of books.

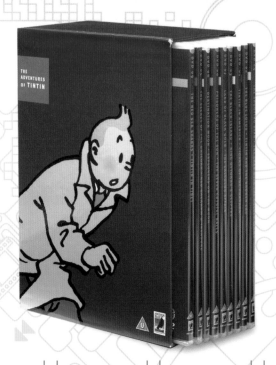

Client: **XL Recordings**
Design: **Patrick Duffy**
Year: **2005**
Country: **UK**

Basement Jaxx: The Videos

The DVD and album covers for this latest Basement Jaxx release—the videos on DVD, and the singles on CD—were designed together. Patrick Duffy's brief for both was to create a bold and colorful cover image and design that would appeal not only to Basement Jaxx fans, but also to all those browsing in record stores. "The idea was to create something simple that referenced the idea of partying in a not-too-obvious way, so the colored stripes were devised as an abstract representation of party streamers," explains Duffy. In addition, he has used Helvetica and Bubbledot typefaces, which have standout in-store and visually represent the excellent dance music tracks that Basement Jaxx produce.

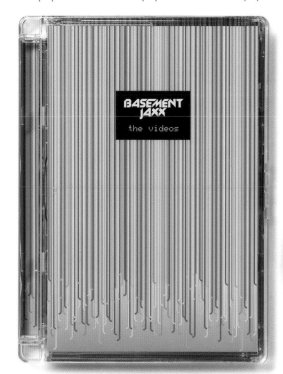

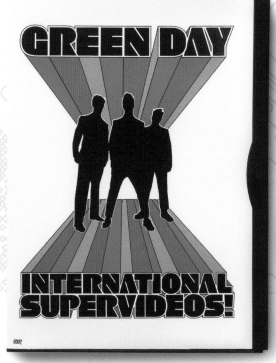

Client: **Green Day**
Design: **Chris Bilheimer**
Year: **2001**
Country: **USA**

Green Day: International Supervideos!

This was part of US band Green Day's greatest hits package. According to designer Chris Bilheimer, the band had mixed feelings about doing a hits record, and had no idea how to package it. "We figured to go ahead and make fun of the concept of the hits record," explains Bilheimer. "The main inspiration for the package was the cheesy greatest hits records that were sold via TV commercials in the 1970s and 1980s. It had to have a tongue-in-cheek feel." The red, pink, and orange color scheme, influenced by 1970s' design, is complemented by the retro 3-D typeface, Geometric885, and silhouette image of the band.

Client: **R.E.M.**
Design: **Chris Bilheimer**
Year: **1996**
Country: **USA**

R.E.M.: Road Movie

This is a cover for an R.E.M. concert, so designer Chris Bilheimer wanted the package to encapsulate the energy and feel of the live show. The cover image was chosen for its intensity of color and blurred motion, and was shot by long-time R.E.M. friend Jem Cohen. The typeface was created using reflective stickers purchased at a truck stop, again referencing the "on the road" idea of touring as a band. The budget was quite small, but strong imagery, a one-color print job, and a matte varnish finish make for an effective DVD package.

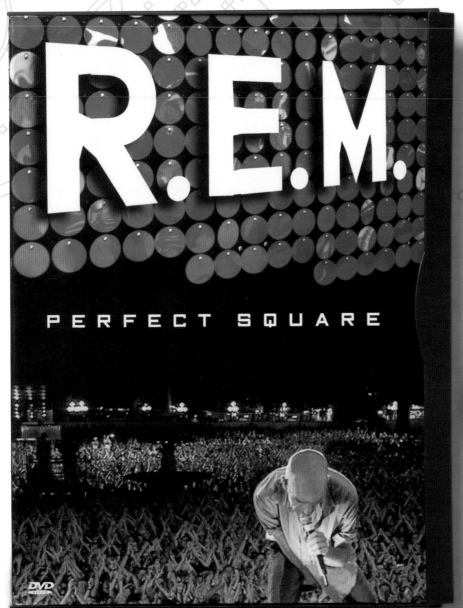

Client: **R.E.M.**
Design: **Chris Bilheimer**
Year: **2004**
Country: **USA**

R.E.M.: Perfect Square

This is the cover for another R.E.M. concert, this time filmed in Wiesbaden, Germany, in 2003. Once again, Chris Bilheimer's intention was to encapsulate the energy and feel of the live show. The image on the cover is a video still that has been touched-up in Photoshop. "For the rest of the package, I tried to use as many stills as possible, so people could see how beautiful the cinematography is," explains Bilheimer. The band logo is a typeface that Bilheimer created; other typefaces used include Bank Gothic and FFGothic.

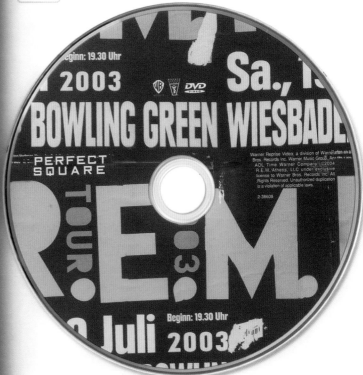

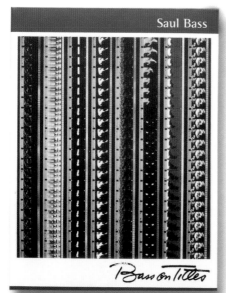

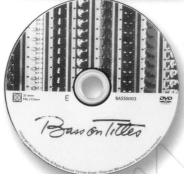

Client: **mediapollen limited**
Design: **Kaigani Turner**
Authoring: **The Pavement**
Year: **2004**
Country: **UK**

Saul Bass: Bass on Titles

This DVD contains a digitally remastered version of a short film created by Academy Award-winning title-sequence designer Saul Bass. It was launched to coincide with a Saul Bass exhibition in 2004 at the Design Museum, London. The package had to reflect that it was a limited-edition collector's item, so a matte finish and a slim, paper-based package were used as an alternative to the traditional Amaray DVD package. The artwork on the cover was modeled after Saul Bass' print work.

Client: **Thrill Jockey Records**
Design: **Funny Garbage**
Drawings: **Azita Youseffi**
Year: **2005**
Country: **USA**

Looking for a Thrill: An Anthology of Inspiration

This charity DVD features more than five hours of interviews with a variety of music-minded individuals, about a music-related inspirational moment in their lives. Interviewees include Thurston Moore, Björk, and Mike Watt. It is a nonprofit project, with all proceeds going to Greenpeace. The package was designed by Matthew Girardi at Funny Garbage. "It had to be a Digipak with a supplemental insert that had all the interviews, plus names and bands, to assist navigation," explains Girardi. "Plus, the Digipak also needed a clear DVD tray so you can view the credits (a great way to save space), and a pocket for the insert, all echoing the menu design of the DVD." The musical instrument drawings were inspired by the poster designs of Josef Müller-Brockman, a pioneering twentieth-century Swiss graphic designer.

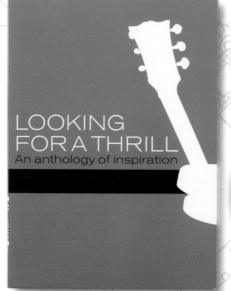

Client: **Pan American/Kranky**
Design: **David Williams**
Year: **2004**
Country: **USA**

Pan American: Quiet City

The audio CD of the album <u>Quiet City</u> comes with a DVD. Both are housed in a double, foldout card package that feels nice to the touch, raw, and "authentic." Its design was inspired by the video essay featured on the DVD, which was shot and edited by Mark Nelson and Annie Feldmeier. The use of cityscape photographs and underwater imagery gives the package quite a dark and mysterious feel.

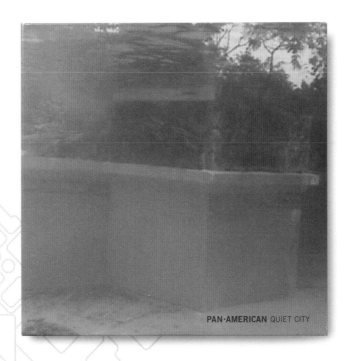

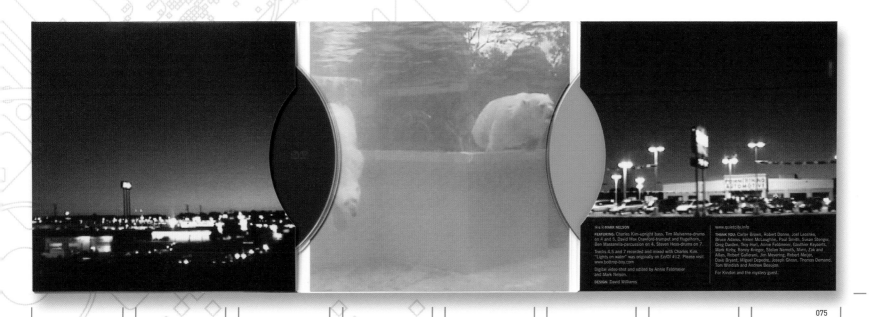

Client: **The Dead Texan/Kranky**
Design: **The Dead Texan/Craig McCaffrey**
Year: **2004**
Country: **USA**

The Dead Texan

The design of this DVD package was inspired by the imagery of The Dead Texan's music videos, and was created by the musicians themselves—Adam Wiltzie and Christina Vantzos—together with Craig McCaffrey. Imagery on the inside of the packaging is taken from music videos featured on the DVD. This foldout card package also contains an audio DVD. Avenir and Avenir Light were the chosen fonts, along with a specially designed typeface created by Adam Wiltzie and Craig McCaffrey which is used on the cover. The illustration really makes this package stand out, and is featured on the discs themselves.

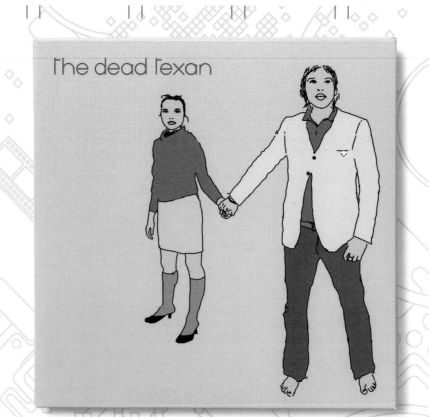

GAS TV-05
Moving image
of London

Hexstatic
Interview
Vector Warren Hill/Brunson
Timber Hardwood remix Warren Hill/Black/More
Robopop Brunson/Warren Hill

Client: **GAS**
Design: **Philip O'Dwyer at State Design**
Year: **2003**
Country: **UK**

GAS TV-05: Moving Image of London

This motion-graphics DVD features the work of some of the UK's best moving-image artists, including Hexstatic, D-Fuse, and Me Company. Asked to create a cover that expressed the DVD's content, Philip O'Dwyer developed an abstract version of the iconic London underground map, printed on the reverse of the DVD, and abstracted it further for the cover images. There is nothing fussy about it, just a clean white background, solid color imagery, and simple text. The case itself is a clear, round jewel box with a press clip.

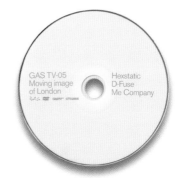

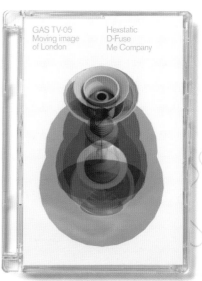

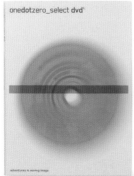
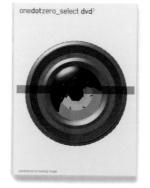
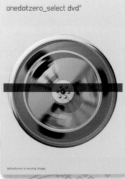

onedotzero_select dvd¹

onedotzero_select dvd³

onedotzero_select dvd⁰

Client: **onedotzero**
Design of DVDs 1 and 3: **Philip O'Dwyer
 at State Design**
Design of DVD 2: **Mark Hough at State
 Design**
Year: **2002–2004**
Country: **UK**

onedotzero: select DVD series

onedotzero is an international digital film
festival, and this series of three discs
features a collection of short graphic and
animated films that have featured at the
festival. The design of the first onedotzero
DVD was an exercise in developing a simple
idea that could then be applied across
several media. The DVD is printed with an
index of the films it contains. When the disc
is played, the on-screen menu features
a spinning disc. The packaging further
develops this theme, resulting in a satisfying
interplay between on-screen, disc, and print
media. This approach was a reaction against
lengthy and complex DVD motion menus.
The subsequent DVDs in the series develop
the theme, adopting further circular physical
objects from the world of film. All the
imagery is computer-generated illustration,
and onedotzero's corporate fonts, which
were designed by State Design, are used
throughout. The packaging used is a four-
panel Digipak with slipcase.

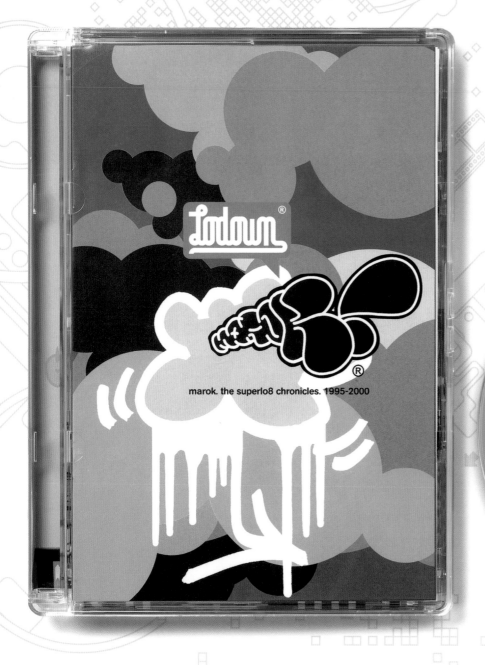

Client: **Gas As Interface Co., Ltd**
Design: **Marok**
Year: **2003**
Country: **Japan**

Marok: The Superlo8 Chronicles 1995–2000

This DVD is a compilation of short flicks, documentaries, and personal tales of skaters and snowboarders, and was shot entirely on super 8mm film. Because the content is black and white, the idea behind the package design was to complement this by creating a colorful cover that drew the viewer in. The design is also based on the unorthodox approach, design, and appearance of creative magazine <u>Lodown</u>, which also produced this DVD. A clear plastic Super Jewel Box has been used as the packaging, and the classic Helvetica and Rounded Helvetica typefaces were used to complement the artwork.

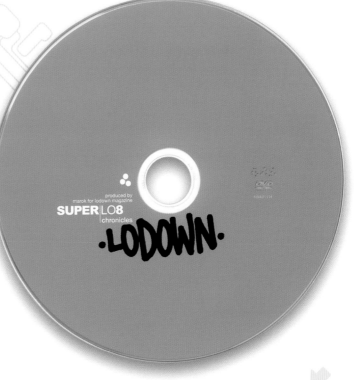

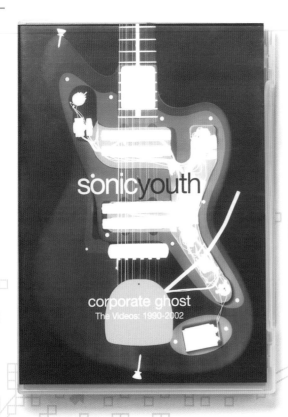

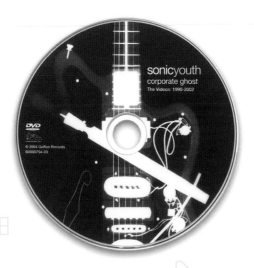

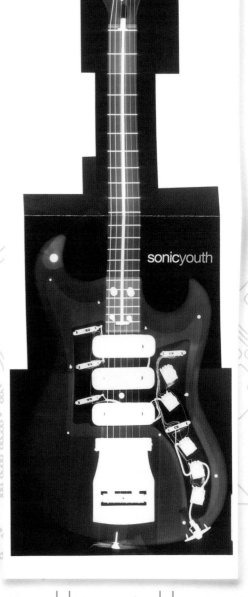

Client: **Geffen Records**
Design: **Frank Olinsky**
Year: **2004**
Country: **USA**

Sonic Youth: Corporate Ghost: The Videos: 1990–2002

This collection of 23 of Sonic Youth's music videos includes three hours of commentary and interviews. Despite the standard Amaray packaging this DVD, designed by Frank Olinsky, is really striking. Inspired by the title, <u>Corporate Ghost</u>, Olinsky x-rayed the band's guitars to create ghost-like images. He then applied them to the cover, disc, and pull-out insert, which makes for a simple, yet high-impact cover. The DVD itself also contains "hidden" features.

Client: **Universal**
Design: **Point Blank Inc.**
Year: **2003**
Country: **UK**

Trainspotting: The Definitive Edition

Cult British film <u>Trainspotting</u> was originally released in 1996, but this special double DVD collection came out in 2003. It features an uncut version of the film, as well as deleted scenes, cast and crew biographies, and a behind-the-scenes photo gallery. Point Blank Inc. used artwork from the original film promotion imagery (designed by Stylorouge), and manipulated it to give lead actor Ewan McGregor a "graffiti" look. They used AG Book Stencil typeface to fit the elements together. The distinctive orange of the original artwork has been retained to stay true to the <u>Trainspotting</u> "brand." A limited run of the package features sandpaper-effect, spot UV on the cover.

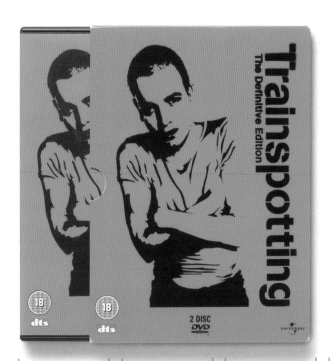

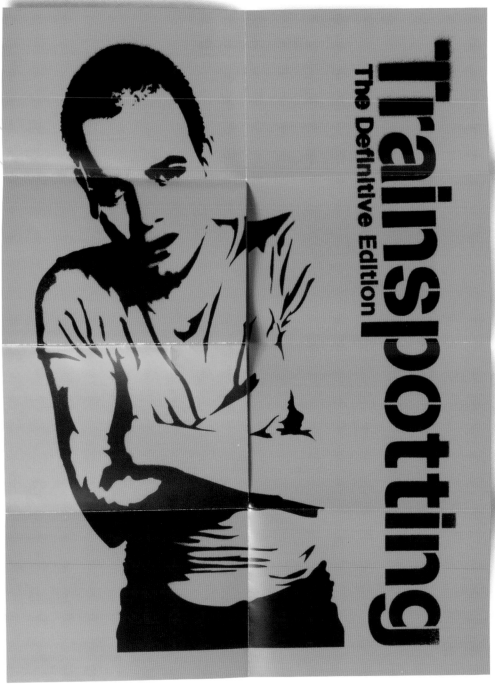

Client: **Universal**
Design: **Point Blank Inc.**
Year: **2003**
Country: **UK**

The Hitchcock Collection

In 2003, designers Point Blank Inc. were asked to rebrand the Alfred Hitchcock collection of films to give it a more contemporary look and make it relevant to today's audience. Using original artwork from each film, the designers stripped the images down to create a series of more modern graphic images. A different image features on the cover of each DVD. The typeface for the covers was taken from the original film text and stripped down to a more simple graphic form. In addition to being modern, the collection had to be cohesive, with the individual DVDs all working together, so the same layout has been used on each cover, with just a different color scheme. The DVDs are housed in a large, solid slip box.

Client: **Barbara Rosenthal**
Design: **Barbara Rosenthal**
Year: **2004**
Country: **USA**

Dog Recognition

This DVD contains a humorous, conceptual, hand-drawn animation about identity, and looks at the idea behind the recognition of others like ourselves. It is set to an audio track of dogs barking. The DVD was made by Barbara Rosenthal, who also designed the packaging. The idea behind the cover was that it should reflect what was happening on the DVD, so Rosenthal used a simple illustration of two dogs, as featured in the animation, together with handwritten type. It makes for a cover that has an element of humor and intrigue.

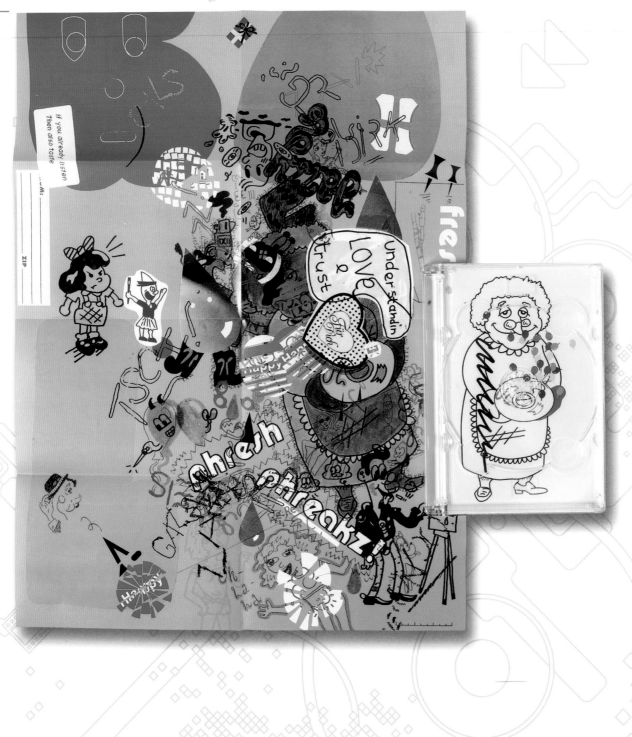

Client: **GAS DVD**
Design: **Reala**
Year: **2003**
Countries: **Sweden/UK/Japan**

Reala

Reala, a design trio, has created music promotion videos for artists including Swedish musician Jimi Tenor and Swedish band The Hives. Their work is known for including cute icons and pop animations. This DVD contains music videos of Reala's own band, plus those of London label Dreck Records. The DVD package, designed by Reala, contains an insert that folds out to a double-sided poster. "One of our main philosophies is to create order from chaos, and the other way around. We therefore decided to have one side of the poster more calm, and the other side handmade, and more chaotic," explains Samuel Nyholm of Reala. Imagery for the cover is a combination of artwork, vector drawings, and handmade drawings by Reala artists.

Client: **F Communications**
Design: **Seb Jarnot**
Year: **2002**
Country: **France**

Laurent Garnier: Unreasonable Live

French designer and illustrator Seb Jarnot has worked with DJ Laurent Garnier on many of his CD packages. For this, Garnier's Unreasonable Live, Jarnot has created another stunning package with his trademark illustration. This illustration combines imagery from previous albums, and includes a fork, a woman, and a big wheel. The DVD contains a video of Garnier live at the Elysée Montmartre, Paris, in 2002, and extended versions of several of his music videos from the Unreasonable Behaviour album. The DVD is packaged in a standard jewel case, and comes with a limited-edition 12-inch single, both of which are housed in an outer box.

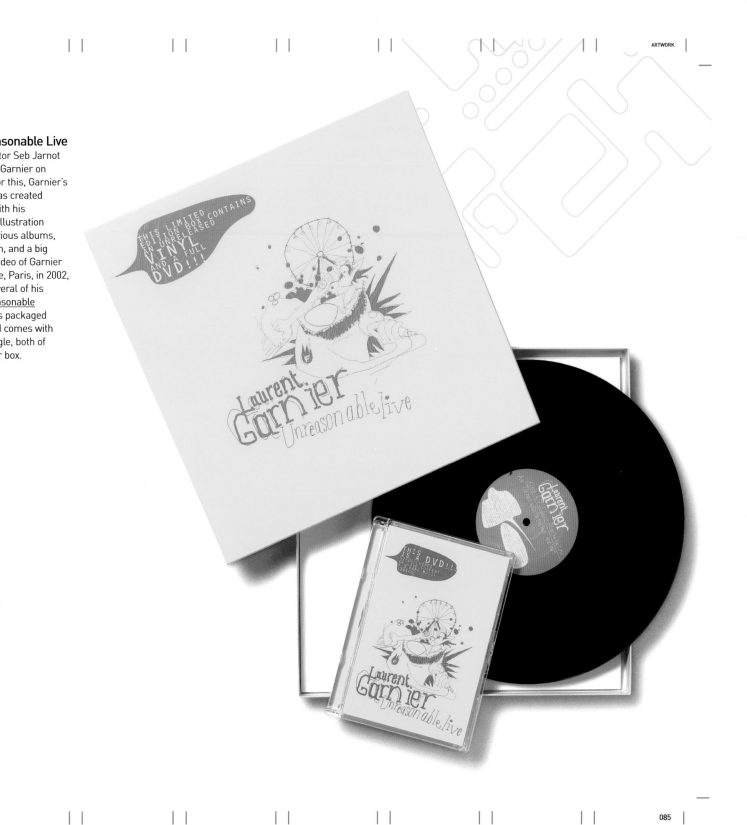

Client: **YouWorkForThem**
Design: **WeWorkForThem**
Year: **2004**
Country: **USA**

Finding Eutaw and North

Finding Eutaw and North is the second DVD release from WeWorkForThem. It comprises six videos, including a title video track, which is an ambient architectural interpretation of the streets of Baltimore, Maryland. The YouWorkForThem team created the custom software to mix the video, and also created the custom audio material for the DVD. The design of the DVD package was inspired by the designers living in, and visiting, Baltimore, and for the cover art they used illustrations from the DVD as well as drawing new images based on their interpretation of the DVD's contents.

Client: **Arthaus**
Design: **Bleed Design**
Year: **2004–2005**
Country: **Norway**

Arthaus film series

The aim of Arthaus (the art film foundation) is to improve the exposure of artistically valuable films in Norway. The brief to the packaging designers for this film series was to create something that would appeal to film enthusiasts and a broader audience. There had to be an identity throughout the series that didn't overshadow the individual films. The "look" had to be modern, but classic. "The connection between the films is obvious, but sometimes we needed to ensure that they retained their own identity, as for American Splendor, where the cartoon-style heading has been retained," explains Heidi Wilhelmsen at Bleed Design. Imagery from the films' posters has been used with a two-color palette for each film to strengthen the identity of the series.

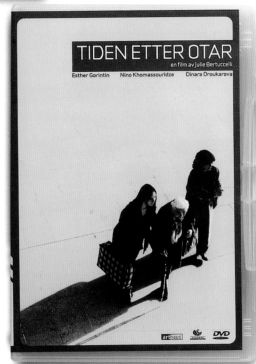

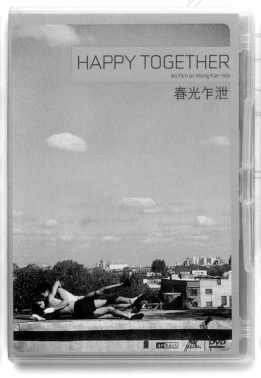

DEN
MEL
a & Luigi Falorni

Å VÆRE OG HA -
EN HYLLEST TIL LIVET
en film av Nicolas Philibert

AMERICAN SPLENDOR

en film av
Shari Springer Berman & Robert Pulcini

LARS VON TRIERS
FEM BENSPÆND
en film av Lars von Trier og Jørgen Leth

Client: **Jonathan Worsley Productions**
Design: **Gentil Eckersley**
Year: **2003**
Country: **Australia**

Sogno d'Amore

Sogno d'Amore is a short film by writer/ director Jonathan Worsley. It explores the bittersweet trials of love and celebrates "post-war dance troupe" the Tivoli Lovelies. This renowned group of dancers and performers serves as a surreal, poignant trigger for questioning exactly what is important. Design agency Gentil Eckersley created the packaging for the DVD, aiming to make it "obvious and appealing." "The Tivoli Lovelies and their heyday—the 1940s—serve as a strong and appropriate visual cue in the design of this cover," explains designer Franck Gentil. Imagery used came from Jonathan Worsley, and a bespoke typeface has been used throughout.

Client: **Territoire de Musiques/
Eurockéennes de Belfort**
Design: **Stéphane Bucco/Sockho**
Year: **2004**
Country: **France**

Made in Eurocks

This DVD documents a performance by musicians An Pierlé and Belfort Sinfonietta in 2004, and contains stills from the concert. Designer Stéphane Bucco created the handmade, hand-illustrated cover for the DVD package. "I wanted to echo the fact that it was a live concert by creating a handmade cover," explains Bucco. "Also, it was a unique concert, never seen before or after." Helvetica typeface has been used together with hand-drawn type on the cover.

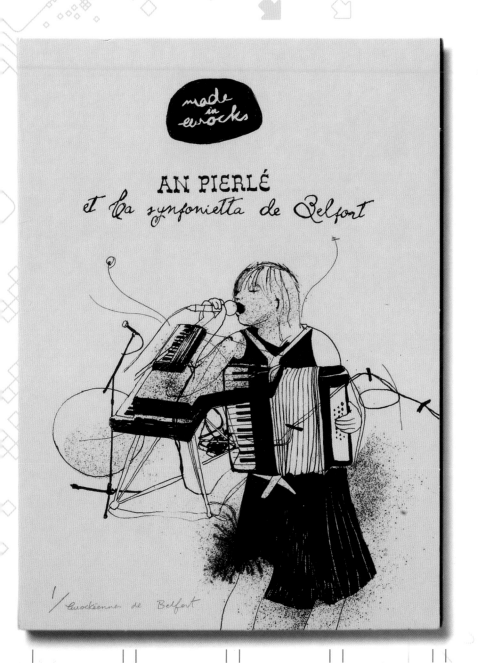

Client: **Jonathan Worsley Productions**
Design: **Gentil Eckersley**
Illustration: **Gypsy Taylor**
Year: **2002**
Country: **Australia**

Satisfaction

Written and directed by Jonathan Worsley, Satisfaction is a humorous short film about sexual fantasy and advertising's exaggerated promise of idealized romance—all set in the context of suburban domesticity. Although intended to reflect feminine beauty, there is an underlying theme of irony and self-loathing throughout the storyline. As coproducer, Gentil Eckersley designed and oversaw the production of every aspect of this film, including packaging, props, and the film's credits, and designed it all to reflect this slightly menacing contradiction. "We played on the themes of visual seduction, with all its appeal, and how this initial, seemingly innocent exuberance, unwittingly, ultimately presents a malign, vulgar picture," explains designer Franck Gentil.

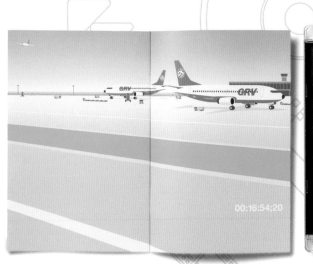
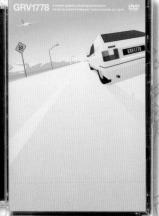

Client: **Gas As Interface Co., Ltd**
Design: **groovisions**
Music: **Yukihiro Fukutomi (rebel/console
 pt. 1–pt. 4)**
Year: **2002**
Country: **Japan**

GRV1778

For this DVD, one of the Gas DVD series, Japanese creative agency groovisions—a graphic artists' agency that also creates motion graphics and art directs projects in sound, film, and fashion—worked with musician Yukihiro Fukutomi to create a 20-minute animated film. The artwork used on the cover and in the booklet is taken directly from the animated imagery on the film.

Client: **Australian Graphic
Design Association**
Design: **Gentil Eckersley**
Year: **2004**
Country: **Australia**

Exhibition memento

Gentil Eckersley created and produced all
the material for the Seventh Australian
Graphic Design Association Awards
Exhibition, including a short film shot by
Anthony Geernaert. The packaging for this
is an "enveloped" poster which was handed
out as a gift to those leaving the exhibition.
The imagery used on the package is derived
from the exhibition structure.

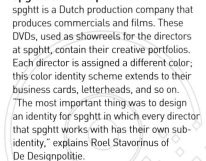

Client: **spghtt**
Design: **De Designpolitie**
Year: **2003**
Country: **The Netherlands**

spghtt creative portfolios

spghtt is a Dutch production company that produces commercials and films. These DVDs, used as showreels for the directors at spghtt, contain their creative portfolios. Each director is assigned a different color; this color identity scheme extends to their business cards, letterheads, and so on. "The most important thing was to design an identity for spghtt in which every director that spghtt works with has their own sub-identity," explains Roel Stavorinus of De Designpolitie.

"We tried to create an effective package using a few elements to make it strong, but simple, so we only used the spghtt logo, subtle lines, and bright fluorescent colors." To achieve the effect of bright fluorescent colors, the ink was printed twice on the paper. Akzidenz Grotesk was the typeface used throughout.

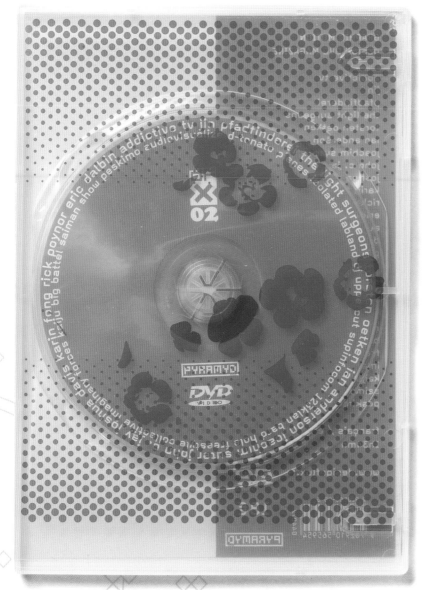

Client: **Editions Pyramyd**
Design: **Fry-Guy, Jaga Jankowska,
 Guy Grember**
Year: **2004–2005**
Country: **France**

designFLUX

designFlux is a video magazine about motion design on DVD, and showcases a variety of designers. The brief for the package design was to use a standard form of DVD packaging to keep costs down. "I came up with the use of a slim, transparent DVD pack, as it enables people to see the DVD and the small booklet inside, as well as giving the overall 'feeling' of something more creative than the standard black DVD packaging with movie-like graphic," explains designer Guy Grember. "I wanted something less aggressive so came up with an angular black pattern over the 'pink' DVD." The cover of the enclosed leaflet features a combination of illustration by Fry-Guy and screenshots from the DVD.

Client: **Stones Throw Records**
Design: **Jeff Jank**
Year: **2004**
Country: **USA**

Stones Throw 101

Stones Throw records was founded in 1996 by musician and DJ Peanut Butter Wolf. This Stones Throw 101 DVD/CD is a celebration of the label's first 101 releases, from 1996 to 2004, and includes both the big hits and the "misses," as well as some previously unreleased tracks. The package for the DVD was created by designer Jeff Jank. He has used a six-panel Digipak, and based the packaging idea on an old library book. The cover features a textured print to give it the look of an old leather-bound book, and inside a mock library book sticker reads "It is the library's responsibility to provide material which will enable the citizen to form his own opinions. Therefore, the library provides books representing varying points of view—Book Selection Policy."

Client: **Artificial Eye**
Design: **01.02**
Illustration for Zatoichi: **Airside**
Year: **2004**
Country: **UK**

Zatoichi, and Histoire de Marie et Julien

These two features are taken from the Artificial Eye series of "art house" films. In designing the covers, 01.02 adopted a marketing strategy, and incorporated this into what has evolved as a house style, not only for DVD releases, but also for Artificial Eye print media. The basic structures and font set are in the Artificial Eye house style, which has been adapted according to content,

and there are always fixed elements on the DVDs that help create a sense of continuity across the back catalog of releases. These formats have to respond to the images, which are key to selling the film, and form a comfortable relationship with the typography.

Client: **Walter Pfeiffer**
Design: **Bureau Des Videos**
Year: **2005**
Country: **France**

Walter Pfeiffer compilation

Walter Pfeiffer began his photography career in the 1970s without any technical ambition, just the desire to provide a new visual vocabulary for beauty, eroticism, and freedom of life. Initially, his work gained recognition through an underground network, and today has reached cult status. This DVD is a compilation of three of Pfeiffer's videos. Designer Nicolas Trembley at Bureau Des Videos created the cover using imagery taken from its content. "We wanted this to be coherent with the DVD," he explains. "Every image we used for the interface and cover has been taken from the video." Trembley has used simple and graphic images that correspond with Pfeiffer's spirit: erotic and colorful.

Client: **Jochens Kleine Plattenfirma**
Design: **Dirk Rudolph and Hosen
 Cover AG**
Year: **2002**
Country: **Germany**

Die Toten Hosen: Reich & Sexy II

Die Toten Hosen's album <u>Reich</u> & <u>Sexy</u> II features their best videos from recent years, and the making of those videos. "For the band's first Best of Reich and Sexy," explains cover designer Dirk Rudolph, "they copied the cover idea from a Jimi Hendrix record, <u>Electric</u> <u>Ladyland</u>, but 10 years on, with more success and 'fame,' the idea was to express the 'reich and sexy' idea by being photographed with more than 70 naked models." The cover and internal pullout leaflet feature photography by Andreas Gursky. If you look closely, you can see the band members in the image. A four-panel Digipak format provides the packaging.

Client: **Corbis**
Design: **Beatte Obermueller**
 at **Segura Inc.**
Year: **2005**
Country: **USA**

Imagine the Possibilities
For this digital image library, the brief was to create a vehicle to help promote Corbis' new department selling images as "art" for flat screens and plasma screens. Housed in a solid jewel box, the package features a large, pullout poster. All the imagery used is from Corbis, the text is set in Helvetica, and the screen-printing process has been used to apply it. A simple design concept, it is effective and delivers what the client wanted.

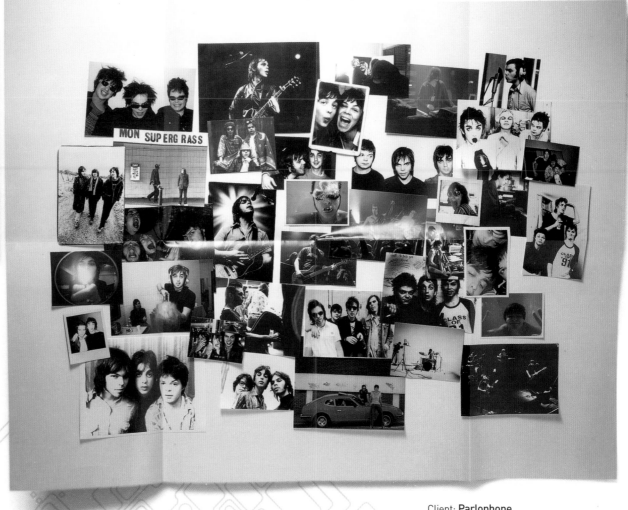

Client: **Parlophone**
Design: **Blue Source**
Photography: **Pete Gardner**
Year: **2004**
Country: **UK**

Supergrass is 10: The Best of 94–04
This DVD release celebrates 10 years of UK band Supergrass releasing records. The cover features a mixture of existing badges sourced from a badge collector and others that were designed and produced especially for this project. The typeface for the "Supergrass is 10" badge is Cooper, which was also used across all DVD listings.

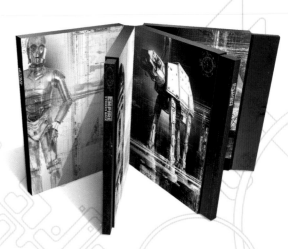

Client: **20th Century Fox**
Home Entertainment
Design: **Neuron Syndicate Inc.**
Year: **2004**
Country: **USA**

Star Wars trilogy

This four-disc box set contains <u>Star Wars IV: A New Hope</u>, <u>Star Wars V: The Empire Strikes Back</u>, and <u>Star Wars VI: Return of the Jedi</u>. It also includes documentaries, and behind-the-scenes and never-before-seen footage. The brief was to create packaging that remained true to the films' mythology and characters. "We're fans of the original three films, and literally grew up with these characters," explain designers Ryan Cramer and Sean Alatorre. "Our approach built its foundation on the idea of the 'narrative.' We wanted to create a package with a pace and a payoff, concealing then revealing with each slipcase or turn of a page. The construction and layout of our box takes you on a journey, much like a great film." All imagery was created from stills captured from each film, which were then digitally manipulated using Photoshop.

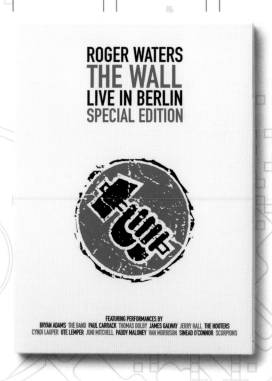

Client: **Universal Music**
Design: **Peacock**
Year: **2004**
Country: **UK**

Roger Waters: The Wall: Live in Berlin

The brief for this project was to create a deluxe package out of an existing DVD title that would reflect the distinction of the new, enhanced Special Edition DVD. The design had to be completely different from the existing standard-version release. The Special Edition features the hammer logo that was visible above the stage for the duration of the concert and is very "clean" in comparison with the standard release.

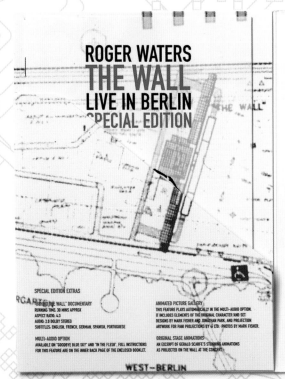

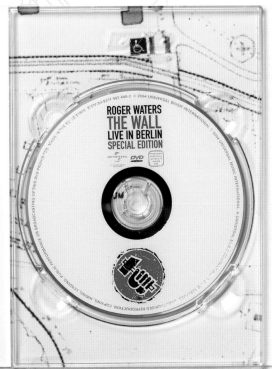

Client: **Palm Pictures in partnership with Spike Jonze/Michel Gondry/ Chris Cunningham**
Design: **Alex Rutterford/The Girl Art Dump (Spike Jonze); Alex Rutterford/ 71 Design Team (Michel Gondry); Alex Rutterford/ Chris Cunningham (Chris Cunningham)**
Year: **2003**
Country: **USA**

The Directors Label series box set

The Directors Label DVD series, produced by Palm Pictures, showcases the work of some of today's most groundbreaking and iconic filmmakers. The first three releases, shown here, feature the work of Michel Gondry, Spike Jonze, and Chris Cunningham. Each edition features the best work in music videos, short films, documentaries, and commercials from these directors, along with new works created exclusively for the series, as well as interviews and commentaries from artists, actors, and other collaborators. "In creating a design concept—The Directors Label—it was important to come up with an esthetic that lived up to the work of the directors; one that reflected their individuality and contribution to filmmaking, while also maintaining continuity for the series," explains Robert Silverberg, director of marketing at Palm Pictures. "The directors were involved in deciding which images from their work appeared on the packaging, including photos, screengrabs, and even the color and font type for their names. What you see is absolutely a reflection of the individual director and their films."

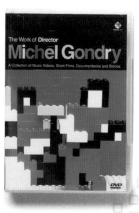 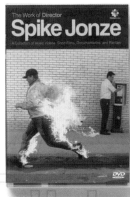 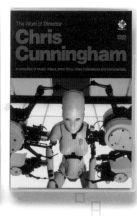

Client: **res magazine**
Design: **Honest**
Year: **2003**
Country: **USA**

res magazine movies

In 2003, New York–based design house Honest was asked to design this package for a DVD of music videos and short movies profiled in res magazine. The brief was to create a design that was based on the theme of travel—something unique that the subscribers to res magazine would enjoy. Inspired by "a bizarre ride on the 'walk-a-lator' in an airport," the designers wanted to create something "fun and unique with characters that you would remember," explains Cary Murnion. The designers created these images for the package, drawing them first in graphite and then coloring them in Photoshop.

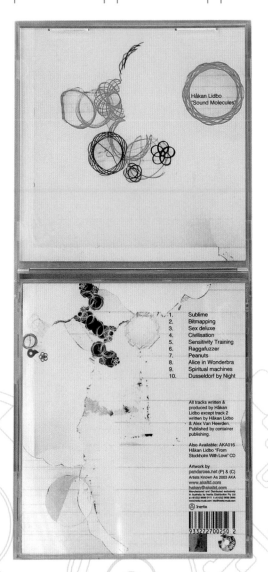

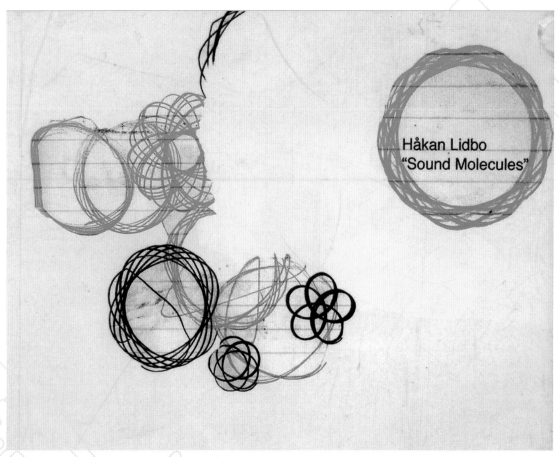

1. Sublime
2. Bitmapping
3. Sex deluxe
4. Civilisation
5. Sensitivity Training
6. Raggafuzzer
7. Peanuts
8. Alice in Wonderbra
9. Spiritual machines
10. Dusseldorf by Night

All tracks written &
produced by Håkan
Lidbo except track 2
written by Håkan Lidbo
& Alex Van Heerden.
Published by container
publishing.

Also Available: AKA016
Håkan Lidbo "From
Stockholm With Love" CD

Artwork by
pandarosa.net (P) & (C)
Artists Known As 2003 AKA
www.akaltd.com
hakan@akaltd.com

Client: **AKA Ltd**
Design: **Pandarosa**
Year: **2004**
Country: **Australia**

Håkan Lidbo: "Sound Molecules"

This CD/DVD contains an album and two videos by Swedish musician Håkan Lidbo. The music is minimal, with an electro feel, whereas the visuals are of an abstract nature, very similar to the visuals on the cover/package. "We knew we were using a simple jewel case, CD size," recalls designer Ariel Aguilera, "but we wanted to use this, as much as possible, to our advantage, and create a graphic for the cover which took advantage of the transparency of the package." To achieve this, the designers created a visual that "wraps" itself around the package and connects all parts of it together, from disc to tray. "We used spirograph drawings and other textural elements to create the imagery," adds Aguilera. "The circular, atom-like structures relate to the title of the release and also to the visuals on the DVD."

Client: **Warp Records**
Design: **Matt Pyke** at
 The Designers Republic
Interface Design: **Matt Pyke**
Interface Build: **The Pavement**
Year: **2004**
Country: **USA**

Warp Vision: The Videos 1989–2004

Warp Records, one of the UK's leading
independent record labels, was founded
15 years ago. This, the first DVD release
from the label, features 35 videos from
artists including Aphex twin, Nightmares
on Wax, Squarepusher, and Broadcast;
a gallery of sleeve art; and a music CD.
Designed by Matt Pyke, then at The
Designers Republic but now at Universal
Everything, the idea was to create a cover
that had impact, and that hinted at the
content of the DVD, but did not directly
relate to any particular video on it. Inspired
by the DVD title, Warp Vision, a simple use
of stock photography achieved this. The
standard Amaray case has been replaced
with a hardback book–style cover that
provides a real sense of weighty quality.
Adding to this is the use of foil blocking
for the title.

Client: **YouWorkForThem**
Design: **WeWorkForThem**
Year: **2004**
Country: **USA**

Enter the Dragon

YouWorkForThem is an independent, online design store based in Baltimore, USA. It sells books, DVDs, typefaces, stock art, and other design essentials. This DVD, Enter the Dragon, was produced and sold by YouWorkForThem, and designed in-house by WeWorkForThem. The DVD contains 26 short videos by some of the best motion designers around the world. The work ranges from stopped motion to live motion, with everything in between. The concept was as follows. YouWorkForThem gave each motion designer a typeface to work with, and the brief was to interpret the typeface in video form. The cover image is an abstract illustration of a panoramic view of a dragon. The package itself is made with matte, lightweight card. Shipping plays a big role in the company's distribution, so card was preferred: not only does plastic crack, it is also more expensive to ship. The interface, also designed in-house, is abstract yet simple.

Client: **The White Stripes, Beggars Group**
Design/Art Direction: **Rob Jones at**
 Animal Rummy
Year: **2004**
Country: **UK**

Under Blackpool Lights

This DVD package was created by designer Rob Jones for the release of The White Stripes' performance at the Empress Ballroom in Blackpool, England. The package was produced with three different colored cases—black, white, and red. Each color case uses different transparencies as inserts within the DVD booklet. This idea came from singer Jack White. He wanted to include something along the lines of the overlays he had used for his childhood etch-a-sketch. Jones worked closely with The White Stripes to work out what imagery should be used on the cover and in the DVD booklet—the band is known for taking a great interest in the design of its products.

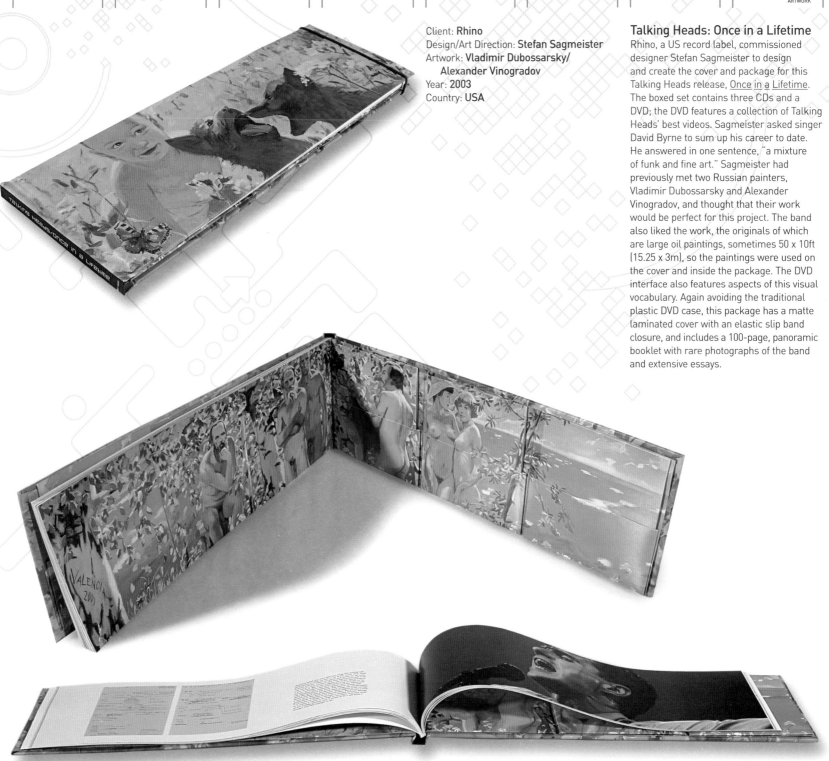

Client: **Rhino**
Design/Art Direction: **Stefan Sagmeister**
Artwork: **Vladimir Dubossarsky/**
 Alexander Vinogradov
Year: **2003**
Country: **USA**

Talking Heads: Once in a Lifetime

Rhino, a US record label, commissioned designer Stefan Sagmeister to design and create the cover and package for this Talking Heads release, <u>Once in a Lifetime</u>. The boxed set contains three CDs and a DVD; the DVD features a collection of Talking Heads' best videos. Sagmeister asked singer David Byrne to sum up his career to date. He answered in one sentence, "a mixture of funk and fine art." Sagmeister had previously met two Russian painters, Vladimir Dubossarsky and Alexander Vinogradov, and thought that their work would be perfect for this project. The band also liked the work, the originals of which are large oil paintings, sometimes 50 x 10ft (15.25 x 3m), so the paintings were used on the cover and inside the package. The DVD interface also features aspects of this visual vocabulary. Again avoiding the traditional plastic DVD case, this package has a matte laminated cover with an elastic slip band closure, and includes a 100-page, panoramic booklet with rare photographs of the band and extensive essays.

Client: **Universal Music**
Design: **Dirk Rudolph**
Year: **2003**
Country: **Germany**

In Extremo

The <u>In Extremo</u> collector's box features striking close-up images of feathers, a snake, a falcon, and wood on its cover. The DVD features live concerts, footage of the band's Mexican tour, and the making of two albums. "This compilation package includes two previously released albums, so I used some of the elements and imagery from those—the feathers, a snake, wood—and combined it with new imagery of a falcon that, in my eyes, symbolizes the band's sound—a mix of metal tunes and medieval music," explains designer Dirk Rudolph. Housed inside the outer box is a 10-panel Digipak and pullout poster—all have a matte varnish finish printed with a Pantone metallic gold background. The band's logo is hand-drawn.

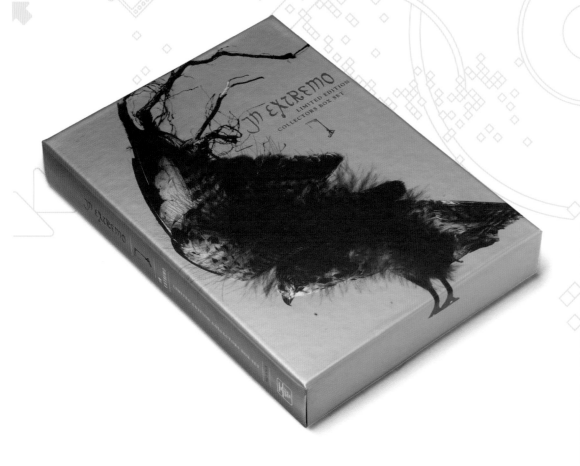

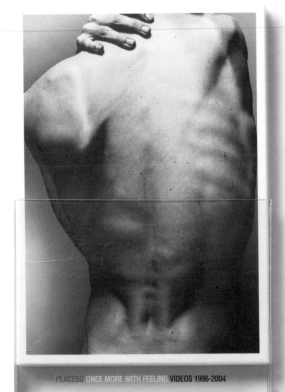

PLACEBO ONCE MORE WITH FEELING VIDEOS 1996-2004

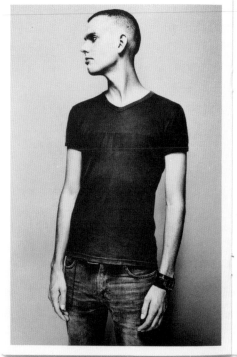

Client: **EMI**
Design: **Alex Cowper/Virgin Art**
Menu/Interface Design: **Abbey Road Interactive**
Year: **2004**
Country: **UK**

Placebo: Once More With Feeling Videos 1996–2004

Since Placebo's emphatic arrival on the music scene in 1996, the band has had much written about their androgynous slant on rock. Once More With Feeling is a chronological compilation that tracks the band's history to date; not a farewell, not a swansong, but a brief recap. As well as the music tracks and video collection, the DVD also includes, among other features, a 35-minute interview and tour footage. The photography, by Nadav Kander, together with the clear plastic slipcase in which the package is housed, bring a beautiful depth, yet simplicity.

Typography

"Typography is one of the first places we look to inspire ourselves. It plays a big role in how we design or redesign film titles for DVD."

Todd Gallopo, Creative Director/Chief Executive Officer, Meat and Potatoes, Inc.

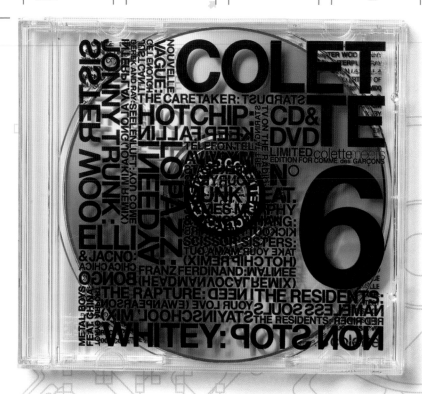 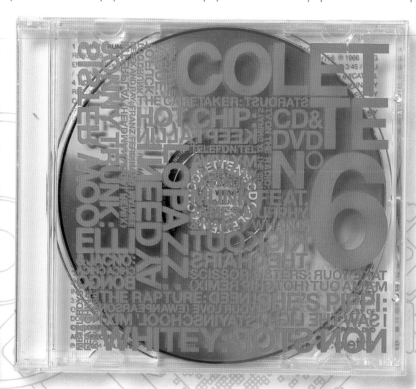

Client: **Colette**
Design: **Work in Progress**
Year: **2004**
Country: **France**

Colette No 6

This CD/DVD is No. 6 in a series of music CDs that French store Colette has released over the years. The difference with this one is the addition of the DVD element. The material on the disc was created by Michel Gaubert and Marie Branellec in conjunction with Geneviève Gauckler. Design of the packaging is courtesy of Creative Director Ezra Petronio at Work in Progress. The design continues the look of previous releases, maximizing the minimalist effect of the transparent jewel case. Only one color is added, in this case red, which is screen-printed in Helvetica type directly onto each cover. The black version, also shown here, is a limited edition for Comme des Garcons. Music on the CD/DVD comes from, among others, the Scissor Sisters, Hot Chip, Jonny Trunk, and Franz Ferdinand. Visuals come from Geneviève Gauckler in the form of cute characters that take the viewer on a journey from Paris to Tokyo.

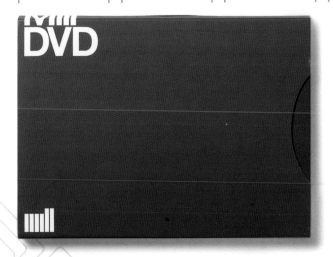

Client: **The Mill**
Design: **Made Thought**
Year: **2004**
Country: **UK**

The Mill

The Mill specializes in high-end commercials and music promos. This DVD was produced to showcase The Mill's recent work to prospective clients. Designers at Made Thought were briefed to create a package that would be "special" enough for the user to want to keep and archive on their shelf. In addition, it was important that the package reflected the visual look and feel of The Mill's identity. The packaging is based on the Burgopak system, which allows the DVD to be presented to the user by pulling the card on the right of the package to reveal the disc on the left. The design has been combined with strong typography, part of The Mill's visual identity, which uses Helvetica Neue to make a minimalist, yet bold package.

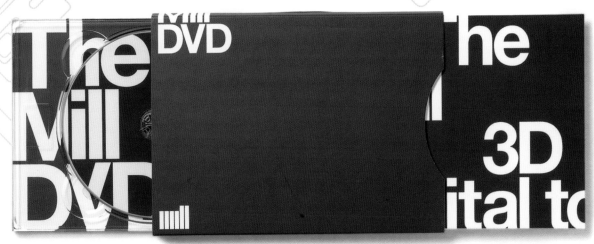

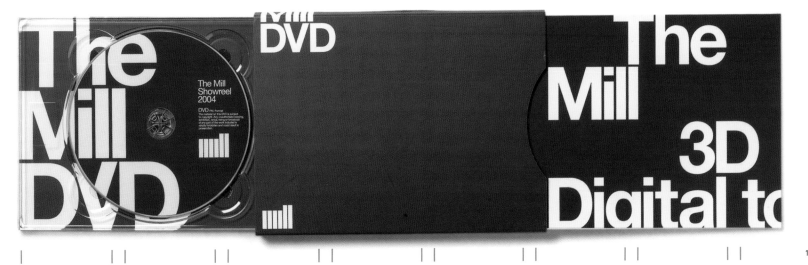

Client: **D-Fuse**
Design: **D-Fuse**
Year: **2005**
Country: **UK**

AV Festival 2003

This DVD is a sampler of the first AV Festival, which was held in UK cities Newcastle, Sunderland, and Middlesbrough in November 2003. The DVD gives an overview of the festival, and contains original film works commissioned by it, including new work by Richard Fenwick and The Light Surgeons. The DVD is for promotional use only, and was distributed to promote the second AV Festival in 2006. Given the large number of contributors to both the festival and the DVD, the brief was to feature a large amount of text, sponsors, and lists of the people involved, while at the same time making sure that the sleeve was vibrant and interesting. The sleeve design is by Michael Faulkner at D-Fuse, and images on the cover have been taken from the films by Richard Fenwick and The Light Surgeons.

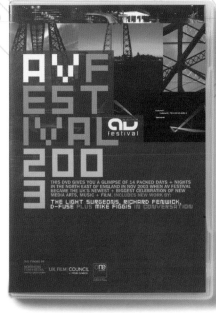

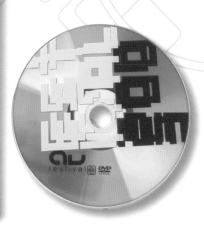

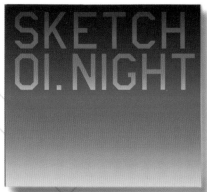

Client: **Sketch/Most Records**
Design: **Yorgo Tloupas**
Year: **2004**
Country: **UK**

Sketch 01. Night

This double CD/DVD was created for a restaurant, Sketch, and features three visual art sequences and music mixed by DJ Boris Horel. Designer Yorgo Tloupas was briefed to create something that echoed the architecture and overall feel of the place, which had inspired the CD/DVD Sketch. The inspiration for the cover came from a room in the restaurant which is painted in a black-red-white gradient from ceiling to floor. The gradient effect was also applied to the font on the cover—one Tloupas designed himself, called USAF, which is

based on an existing font, Amarillo USAAF. A CD-sized six-panel Digipak has been used with a gloss finish to make for a simple, neat, effective package.

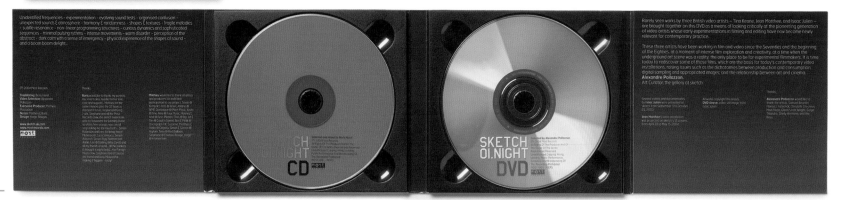

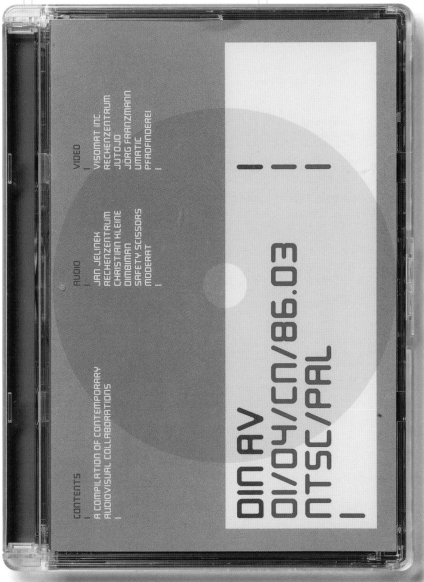

Client: **dvdscape (a division of scape)**
Design: **ABVK (Alex Baumgart in
collaboration with Visomat Inc.)**
Year: **2004**
Country: **Germany**

DIN AV: 01/04/CN/86.03

This was the first release on scape sublabel, dvdscape. It highlights the personal and general development within VJ culture, in which any division between art, commissioned work, club, and high culture has become irrelevant. Initiated and curated by Visomat Inc. (dedicated to the visualization of music between media art and club culture since the mid-1990s), this first installment of an upcoming series provides insights into the vibrant and multifaceted club video scene. Whether medial space design, installation, concept art, entertainment, or simply esthetic backdrop, the VJ mixes featured (set to the music of their choice, and between seven and ten minutes long)

celebrate the renunciation of, and return to, the video clip with work from, among others, Jan Jelinek/Visomat Inc., Christian Kleine/Jutojo, and Safety Scissors/U-matic. As well as the six music/video mixes, the DVD also includes two screen savers and interviews with all artists. A Super Jewel Box has been used to make the product more solid and attractive, and the design uses a simple, three-color palette and minimal typography.

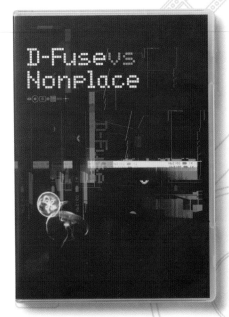

Client: **D-Fuse**
Design: **D-Fuse**
Year: **2003**
Country: **UK**

D-Fuse vs Nonplace

This is a VJ-mix DVD originally commissioned by Nonplace records. It features footage from a video/audio-mix program by Nonplace that was featured on music channel VH1. The cover art and packaging was created by D-Fuse, who built a montage image using stills from the video and their own graphics. Screen Matrix and Bell Gothic fonts were used for all text.

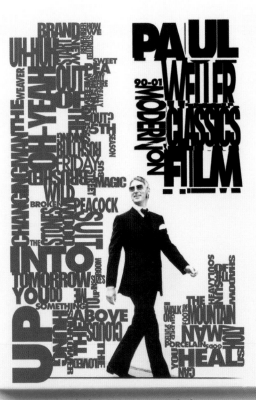

Client: **Island Records**
Design: **Simon Halfon**
Year: **2004**
Country: **UK**

Paul Weller: Modern Classics on Film 90–01

When The Jam broke up in the early 1980s, lead singer Paul Weller formed The Style Council before going solo in the 1990s. This DVD set contains more than a decade's worth of his songs and music videos, as well as interviews and footage from live performances. The cover, designed by Simon Halfon, uses interesting typography and a simple, classic shot of Weller (by Lawrence Watson). The six-panel Digipak has a simple, clean design and a high-gloss finish.

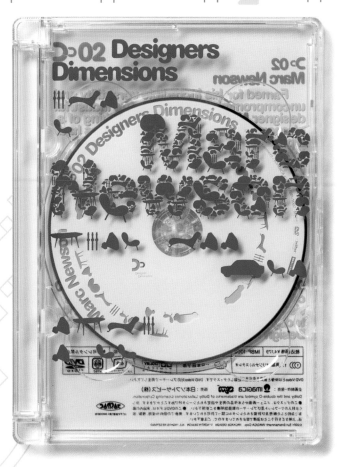

Client: **Syn Entertainment**
Design: **North**
Year: **2004–2005**
Countries: **UK/Japan**

Designers Dimensions:
Marc Newson

Marc Newson is one of the world's best-known and successful designers. In 2005 he released this DVD, which documents his varied and interesting career. Designers at North were commissioned by Nick Wood at Syn Entertainment to create the package for the DVD. Having worked on projects for the company before, the brief was very open, and North was simply asked to design something appropriate to Newson's work. The main idea for the design was to make a package without any paper in it. "We wanted to use the transparent properties of the Super Jewel Box to create an interesting physical piece," explains Stephen Gilmore at North. The company created outline drawings of Newson's most iconic works, which can be seen on the package, and then used them to create a bespoke typeface spelling "Marc Newson" on the cover. Conventional screen printing was used to apply the graphic elements, and AG Buch bold typeface was used for all other text. "We think that not using paper inserts is distinctive in DVD packaging, and hope to build on this as the recognizable house style for future issues of the Designers Dimensions series," says Gilmore.

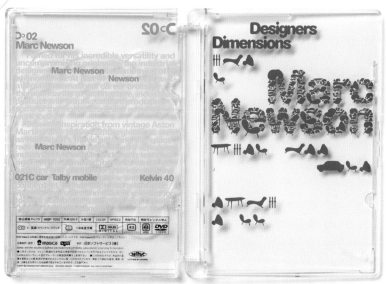

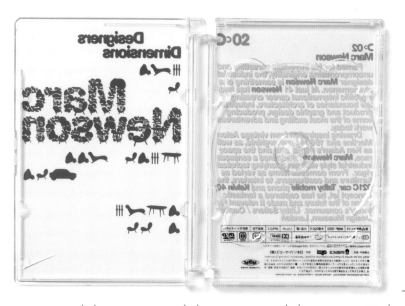

Client: **Syn Entertainment**
Design: **North**
Year: **2004–2005**
Countries: **UK/Japan**

Syn 2005/Free

This double DVD-and-CD pack contains the creative work and showreel of Syn, a Japanese entertainment production company. The showreel DVD is accompanied by an audio CD which features Free, a single created by Syn Creative Director Nick Wood, and used in Japan to promote the Talby cellphone, which was designed by Marc Newson. "We have a good working relationship with Nick Wood," explains Stephen Gilmore at North. "He just explained that he wanted a double-pack DVD and left it to us to come up with something." To be slightly unconventional, the designers created a pack in landscape format. And, building on the style of typography and imagery used on the Designers Dimensions: Marc Newson DVD (see page 117), they created a series of images of items that relate to the content of the discs. Items from the Syn sound studio, which include cables, headphones, and tape reels, were used to create "2005" on the cover, and components from the Talby cellphone form the word "Free." AG Buch bold typeface has been used for all other text.

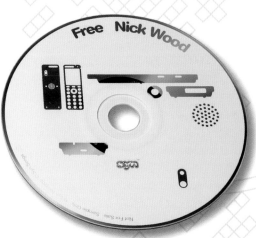

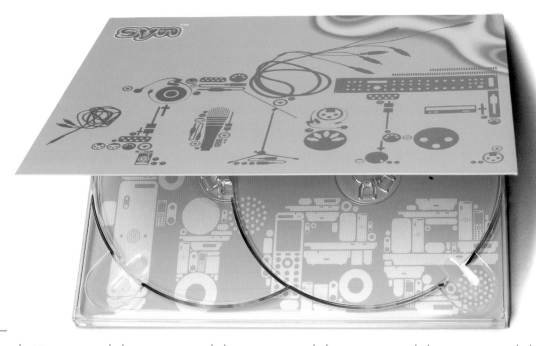

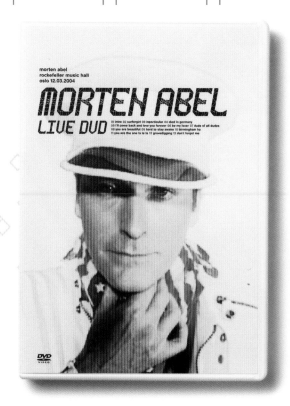

Client: **Morten Abel/EMI Music Norway**
Design: **Christian Schnitler/Gøran Frilstad/E. J. W. Eriksen at Union Design**
Interface Design: **Union Design**
Direction/Photogrpahy: **Lars M. Kræmer/ Pål M. Rossing at Transmission**
Year: **2004**
Country: **Norway**

Morten Abel: Live

This DVD features an edited live concert, interview, road movie/documentary from a tour, and backstage footage of musician Morten Abel. Union Design created the interface and packaging for the DVD, with the main objective being to capture the "live" feeling. The cover is simple, as the clients were keen for it to conform to their idea of selling items, which ruled out any ideas about sophisticated packaging and even a different color scheme. Designer Erik Johan Worsøe Eriksen says "Keep it simple to get a good placement in the shop shelves, and always put the face of the artist on the front so that the fans understand what the product is." The designers made the most of the brief, making a simple but strong cover, and designed a bespoke typeface to use alongside Helvetica Rounded to give the product a stronger identity. Imagery used on the cover is taken via a TV screen, rather than a screen grab, to keep the coarse screen features and make direct reference to the "real" product inside the packaging—the film.

Client: **Reprise Records**
Design: **Frank Olinsky**
Year: **2004**
Country: **USA**

Secret Machines: Sad and Lonely

This simple card slipcase cover was created for the release of a promotional DVD by the band Secret Machines in 2004. Designed by Frank Olinsky, the packaging concept had to relate to the band's CD release, Now Here is Nowhere, so a similar white-on-white color palette and the letters from the CD cover were used. These letters were made using cardboard cut from one large sheet; the DVD cover features the "negative" letters created from this process.

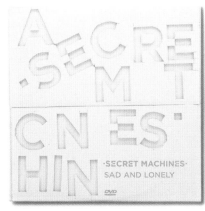

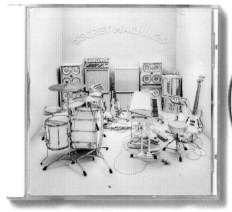

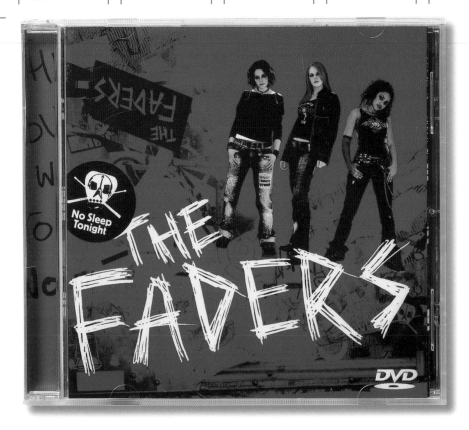

Client: **Polydor**
Design: **Paul West/Paula Benson/
 Nick Hard/Andy Harvey at Form**
Photography: **Valerie Phillips**
Year: **2005**
Country: **UK**

The Faders: No Sleep Tonight

The brief to the designers of this DVD package was to design a format for the release of UK band The Faders single, which could be racked in-store alongside the two audio CD formats for the same track. The package itself is fairly standard, using a CD jewel case, but interesting design gives it standout. The band's logo is influenced by the kind of graffiti that you see scratched onto train windows and bus shelters. "We wanted it to feel gritty and hand-created," explains Paula Benson at Form, "so most of the package contains handwriting and taped pieces of paper which we scanned and distressed." The photography used on the cover and poster were also manipulated and distressed. Along with the handwritten typefaces, Block and Brush Script were used.

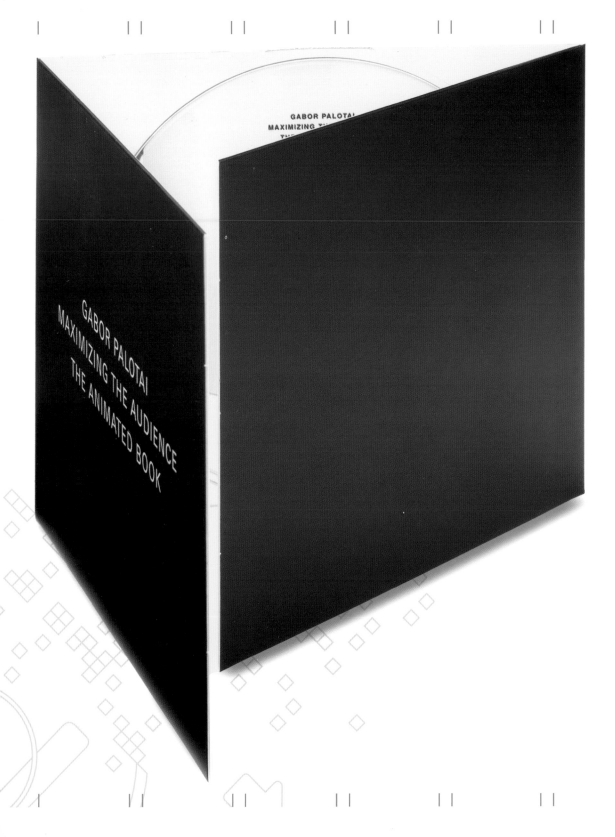

GABOR PALOTAI
MAXIMIZING THE AUDIENCE
THE ANIMATED BOOK

Client: **Gabor Palotai Design**
Design: **Gabor Palotai**
Year: **2001**
Country: **Sweden**

Gabor Palotai: Maximizing the Audience: The Animated Book

Maximizing the Audience: The Animated Book is an adaptation of a book to DVD format. The original book covered all aspects of Swedish graphic designer Gabor Palotai's work, and this has been translated from 2-D to 3-D on the DVD, which also features music composed by Palotai. The idea behind the packaging was to make something very simple and controlled, using only a black-and-white color palette, and with no imagery. Although a standard, CD-sized, six-panel Digipak has been used, the result has a simple, controlled esthetic. A matte finish, no imagery, and the distinct lack of text encloses a vibrant film.

Client: **Rebuild All Your Ruins (RAYR)**
Design: **RAYR/Michael Haleta/Suzy Cho**
Year: **2004**
Country: **USA**

Nicedisc

This DVD contains three abstract art videos. The idea behind the packaging was to create a minimal look that reflects the tone of the videos. "The DVD comprises mainly color patterns and abstract sounds, so it was crucial that the packaging matched that," explains designer Jeff Pash. The use of a bold typeface on an otherwise plain cover gives the package a clean, simple, yet distinct look. The DVD case used is a king-sized Super Jewel Box.

ALL AUDIO + VIDEO COMPOSED BY NICEDISC
(JEFF PASH + NICK PHILLIPS)

RECORDED IN:
LOS ANGELES NOVEMBER 2002
MINNEAPOLIS JUNE 2003
NEW YORK OCTOBER 2003 to JANUARY 2004
MASTERED IN:
NEW YORK JANUARY 2004

DESIGN BY:
SUZY CHO + MICHAEL HALETA

FOR MORE INFORMATION
VISIT http://rayr.net
CONTACT nicedisc@rayr.net

Client: **Stocktown**
Design: **Axel Isberg/Stocktown**
Year: **2005**
Countries: **Japan/Europe**

Stocktown: A Global Underground Journey

This music documentary explores the more interesting lifestyles and independent music scenes from around the world. In nine episodes, Stocktown documents the urban culture movement from, among others, Los Angeles, Sydney, New York, Hawaii, and Tokyo, and aims to give the viewer a personal, straightforward guide to an experimental, global, young, and independent world. It mixes a wide range of music, animations, art, and interviews from more than 40 featured artists, including Kool Keith, Princess Superstar, street photographer B+, and the Waikikii B-boys. Housed in a transparent case, the cover art features the "tags" of each artist featured on the DVD, together with other text set in Yearbook and Courier. "The idea was that the artists created the content, and therefore should also create the package design," explains designer Axel Isberg.

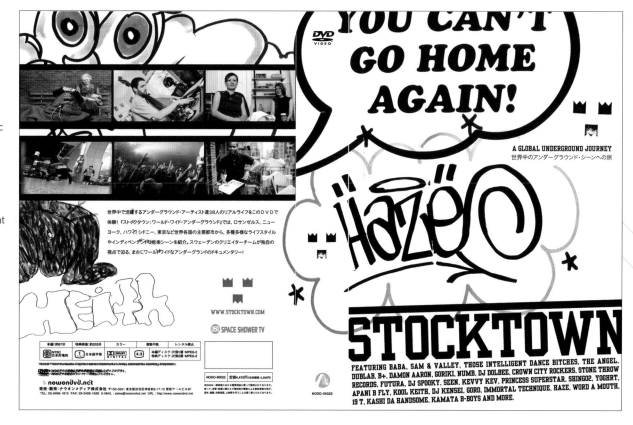

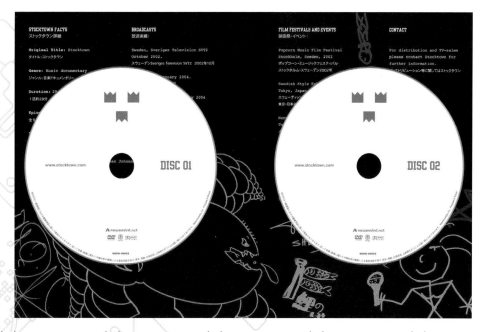

Client: **A.P.C.**
Design: **Rik Bas Backer**
Year: **2000**
Country: **France**

Zoe Cassavetes: Men Make Women Crazy Theory

This package contains a short film on DVD and a soundtrack on CD. Inspired by the type seen on 1970s' cinema posters, designer Rik Bas Backer created this cover artwork using screenshots from the film and type. "We didn't have a lot of time to do this, but I watched the film, did some sketches, and the client decided to go with it," Bas Backer explains. MT Headliner typeface has been used throughout, and printed over the images to get the color mix.

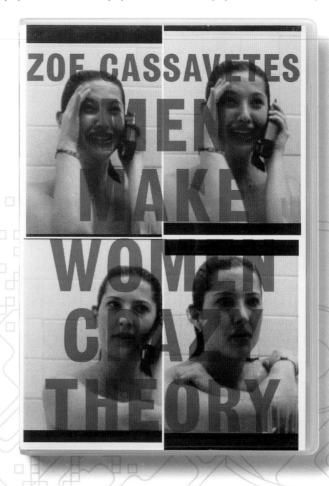

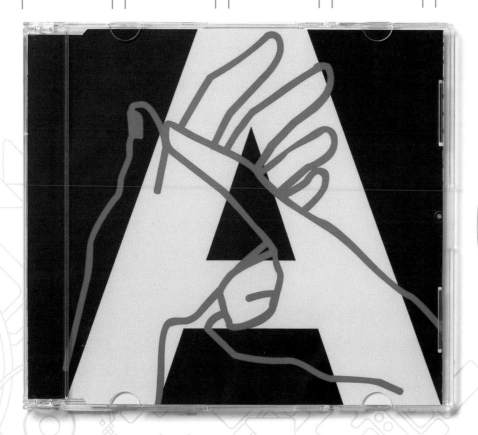

Client: **Martina Klich**
Design: **Lars P. Amundsen**
Year: **2005**
Countries: **UK/Spain/Norway**

Try Hard

This DVD contains a short film about deaf adolescent girls and their hearing peers, and the communication problems they face between one another. In collaboration with the director Martina Klich, designer Lars P. Amundsen created the title sequence and credits for the film. "The idea I proposed was to use the two distinct visual systems—the alphabet and signwriting—like the two main characters in the film," he says. "For the front cover I stripped away most of the context and ended up with the first letter of the alphabet because I wanted to create a strong visual image." He used two fonts for the design—Verdana and BDA Fingerspelling—both on the actual DVD and on the packaging. This is not a mass-produced DVD, but a small-edition, hand-finished, in-house product, using desktop printers. Being a two-color job, it is easy to reproduce.

Client: **Rojo**
Design: **Neasden Control Centre**
Animations: **Neasden Control Centre/Glaznost**
Video Effects: **Alex Beltran**
Year: **2004**
Countries: **UK/Spain**

Distancia Beisbol Tres
Distancia Beisbol Tres features an experimental short film about a love story. The cover makes use of imagery that directly relates to the title sequence on the DVD, which the designers also created. It also features hand-drawn typography.

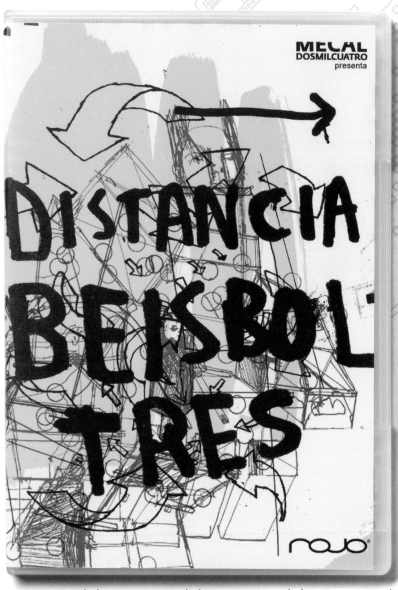

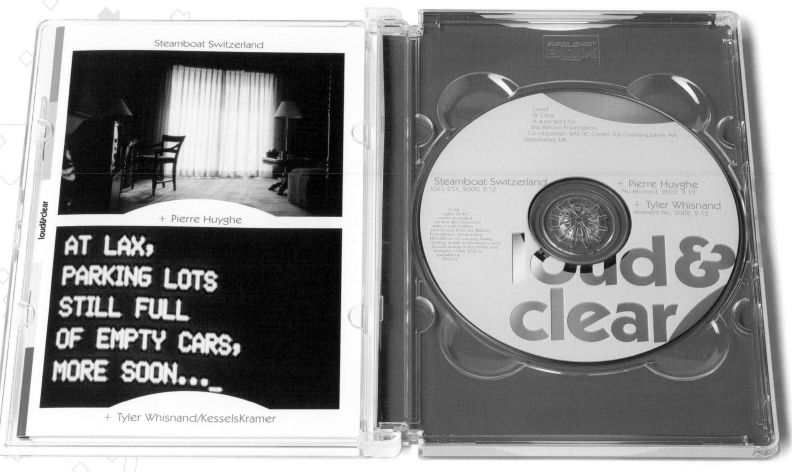

Steamboat Switzerland

+ Pierre Huyghe

AT LAX,
PARKING LOTS
STILL FULL
OF EMPTY CARS,
MORE SOON..._

+ Tyler Whisnand/KesselsKramer

Client: **The Bifrons Foundation**
Design: **Tyler Whisnand/Pierre Huyghe**
Interface: **The Bifrons Foundation**
Year: **2004**
Country: **The Netherlands**

Loud & Clear

The Bifrons Foundation was set up in the Netherlands in 1998, with the aim of bringing together the independent disciplines of contemporary music and contemporary art in the broadest sense, organizing interdisciplinary projects with an international collection of contributors. Loud & Clear is one of its projects. Through this, composers, artists, and other creatives collaborate to make a series of videos for DVDs. This particular DVD features a collaboration between filmmakers Tyler Whisnand (of KesselsKramer), and Pierre Huyghe, and composers Steamboat Switzerland. "The film on the DVD was inspired by the Steamboat Switzerland music," explains Whisnand. "It gave the impression that something enormous and

epic was about to happen, so Pierre and I discussed the fact that it would be interesting if nothing happened at all, that the music would create this powerful tension and anticipation and the image would be more quiet or mysterious in its manner." In short, the film features an empty hotel room; a television is on, but there is no one there to watch it. Information about nonevents is fed onto the television screen, with each phrase on the monitor starting out as an epic story, but ending with a twist of the ordinary or nonepic. Imagery used within the packaging has been taken from the film. The interface, created by Bifrons, is fairly simple, allowing viewers to go directly to the moving images. The package was designed by the filmmakers and uses a clear plastic Amaray case.

Client: **Palm Pictures/Paul Morley**
Design: **Big Active**
Design/Art Direction: **Matt Maitland at Big Active**
Year: **2003**
Country: **UK**

The Last Minute

This cover was created by design group Big Active for the DVD release of the movie The Last Minute. Designer and Art Director Matt Maitland has combined imagery taken from the film with interesting use of type and typographic arrangement.

Peter Chadwick, Creative Director, Zip Design, UK

When approaching a DVD cover design, what inspires you?
This really depends on the client, the brief, and the budget for
the project. I will approach a DVD cover pretty much in the same
way as a CD cover, but will always bear in mind that the content
is not only musical, but visual as well.

How does it compare with CD album cover design?
The design rules are very similar to that of a CD cover. The big
difference at the moment is the packaging solutions afforded
to DVDs. The packaging and stock use on offer is not as wide-
ranging as that for CDs.

**How much of a role do you think the designer plays as a
marketer in the retail environment?**
First and foremost it is the content of the product that sells the
DVD. A bad cover will not harm the sales of a good or interesting
DVD. While the cover will not sell a product, I think it is vitally
important for the whole package that the cover is considered
and designed to enhance the look of the product. On the flip
side, I have often been drawn into buying a DVD or CD that I do
not want purely by the look and feel of its design and packaging.

**What can designers, or those in the music industry, do to
encourage people to continue to buy albums on CD rather than
download? Do you think that including DVDs helps?**
While the use of the Internet for MP3 and shopping, for example,
is experiencing a massive growth, this way of shopping is very
useful and convenient yet an insular activity. I do feel that the
social shopping experience, while not as popular as when I was

a kid, is still alive and well. The difference now is that we have
so much more choice in the way that we can shop. The need to
converse and socialise with other people will continue to drive
the more traditional shopping methods, and certainly with the
introduction of DVD this offers the consumer a cost-effective
product that contains more than one element.

**DVDs largely remain packaged in different variations of the
standard plastic jewel case cover. What can be done to make
these packages more distinctive or innovative?**
Print directly onto them and avoid any paper parts. This is
something I would like to do with the right project. There is a lot
that can be learned from what has been done in CD design, just
like we adapted from vinyl to CD. As ever, if you look back you
will find something engaging that will spice up the future.

Given an unlimited budget, how would you design a DVD cover?
I would look at more traditional methods that have been used
in CD packaging for many years, such as screen printing and
letterpress text, and introduce these methods directly onto
the raw packaging of the DVD, such as the plastic outer cases.
It would be great to spend a lot of the budget on interesting
packaging, but I think there is a lot of scope to push the existing
packaging a lot further with the use of print.

Erwin Gorostiza, Sony Urban Design Director, Sony, USA

What do you think about DVD packaging and menu design in general—what makes a good one or a bad one?
A great DVD package is one that extends the concept of the program. An example, the DVD collection of the series Six Feet Under season one, had a box that opened much like a casket, yet was subtle, much like the show. Another recent package I liked was Northern Exposure, another TV series collection. The exterior package was wrapped in a down jacket–like material with a functioning zipper, conveying a central character of the TV show: the location—Alaska. In terms of menu design, simplicity without compromising creativity makes the best menus. I find too many elaborate menus on numerous DVDs. I love inventive interface. But let's not forget the point of these menus: to drive the user/audience to the content. At times, the menu interface is so complicated—or worse, hidden—that the user experience can be very frustrating. Design should not compromise usability.

What is the most important aspect of DVD packaging?
The exterior package. It must serve many functions, from conveying the central concept of the program to standing out from a very crowded retail environment, competing for consumers' short attention spans. This is not an easy task when you throw in very tight budgets. Menus, as important as they are, are a user-experience after you have purchased the DVD. Consumers aren't driven to purchase the DVD based on menu designs as they have yet to experience them. So the exterior package becomes the vital element, the main tool for seducing consumers to purchase the DVD.

What can the film industry do to encourage people to continue to buy films on DVDs?
The industry should provide more interesting packaging and interior packaging materials. DVD bonus content has its own separate budget. Those behind-the-scenes documentaries are increasingly being shot at the same time as current film production. Separate budgets are allocated for this and yet, when it comes to packaging, the budget is minuscule. Bonus content will not deter people from downloading. The physical packaging—and special packaging especially—is not something you can download. The experience of opening up a cool package with unexpected surprises built into the product makes the user-experience more special.

What can be done to make DVD packages more distinctive or innovative?
More money! We are only limited by how much these products are allocated in their budget for marketing. There is a reason why so many titles are released in a standard jewel case cover, or Amaray package: costs. Special packaging eats into the profits. But manufacturers must start investing in alternative packaging. Video killed the radio star. The Internet killed the video star. Or it may, very shortly.

If there was no limit to the budget, how would you design a DVD cover?
As elaborate as possible with an extensive booklet.

04

"I tend to buy DVDs which are well packaged and designed, and those with significant, well-produced extra content."

Richard Brown, Producer, Palm Pictures

Extending the Experience

Introduction

It is always good to get something extra when you buy anything, especially when it is a DVD of your favorite film digitally remastered, or your favorite band live in concert. The paraphernalia that comes with a package that has added extras is a fanatic's and collector's dream, and as this chapter shows, these added extras come in two forms—the physical and the digital, from headbands and original posters, to secret or "hidden" digital footage.

The reasons for adding extras are varied, but the higher costs involved in manufacturing anything other than a standard-size format means that this is only done in exceptional cases. Hence, many of the projects shown in this chapter that feature physical extras were made for promotion reasons or are limited-edition collectors' items, costing much more than the average DVD.

The DVDs that feature hidden digital extras are generally the same price as normal DVDs, but have that all-important element of discovery. They give the consumer a sense of achievement when they finally find the film or footage, and a feeling of "being in the know." For those who don't want to search, you can now buy a book that tells you how to find these hidden films or live footage on some of the more popular DVDs.

Both digital and physical extras are great ways for the designer to give something extra to the consumer. For the film and record industries, extending the consumer experience in such ways means that they are tapping in to another selling opportunity, but with consumers buying them and enjoying them, both sides are winning.

Digital

"I love a DVD that has a unified feel to it. The menus,
 video, and package should all work together."

Chris Bilheimer, Graphic Designer, 3

Client: **Yoshi Sodeoka/Jason Mohr**
Design: **Yoshi Sodeoka/Jason Mohr/C505**
Year: **2002**
Country: **USA**

40 40 31

This is a limited-edition, handmade experimental art DVD containing 31 minutes of ambient sounds and visuals. It was designed and art-directed by Yoshi Sodeoka and Jason Mohr, who wanted to show that the DVD medium could be designed in a different way to the usual DVD releases. "We wanted to create an art object rather than a typical-looking package, to sort of treat it as a piece of sculpture," explains Sodeoka. The transparent nature of the package, with only text on the cover (set in Helvetica Neue), gives the DVD a sense of simplicity. In addition, there are 10 minutes of "hidden" footage of the dawn of the new millennium breaking on an Australian beach.

Client: **EMI Music Catalogue Marketing**
Design: **Andrew Day for the Red Room**
at EMI
Interface/Menus: **Abbey Road Interactive**
Year: **2003**
Country: **UK**

Duran Duran: Greatest

This DVD contains 21 of Duran Duran's pop videos plus hidden extras. Designed by Andrew Day, the simple, white, embossed, eight-panel Digipak package opens up to reveal a swathe of color strips, each of which has been taken from one of Duran Duran's videos, a palette that spans 25 years of video-making. Opening the DVD further reveals a completely white inner with two plain silver discs. If you look closely, the outer panels contain all the track listings and credits in a very subtle spot varnish. "Duran Duran's early videos have had a huge influence on shaping the pop-music video-making that we see today, so I felt it important to create a package that fully acknowledges this, yet remains austere and understated," explains Day. On the DVD itself, the design and animation for which was also created by Day, are many hidden extras, including Girls On Film (long, uncensored version with alternate ending), New Moon On Monday (four alternate versions), and an interview with Nick Rhodes and Simon Le Bon discussing the recording and production of the album Seven and the Ragged Tiger. In addition, when using the CD-Rom on a computer, users can create their own unique desktop picture using different backgrounds and photographs of the band members.

Client: **BMG/RCA**
Design: **Christian Clabro**
 at **Growing Studio**
Art Direction: **Erwin Gorostiza**
Year: **2004**
Country: **USA**

Elvis '68 Comeback Special

This DVD contains Elvis' 1968 concert, which was originally filmed for NBC TV. It had been over seven years since Elvis had appeared on stage, and as a result the concert was billed as "the comeback" of Elvis. The DVD contains more than seven hours of content, including alternate takes, outtakes, and edited footage. The opening menu design mimics a scene from the show Trouble Man, where Elvis is shot in close-up throughout the entire performance of the song. At the end, the camera pulls back to reveal that Elvis has been standing surrounded by numerous red lights spelling out his name. The designers used this for the prime design element as they felt that the image evoked the symbol and legacy of Elvis. The brief was to make the package "cool and contemporary," to appeal to a younger audience without alienating the hardcore Elvis fan. Using the aforementioned sign, the designer created a dot-pattern logomark, and used the red dots consistently throughout the DVD Digipak, booklet, and labels.

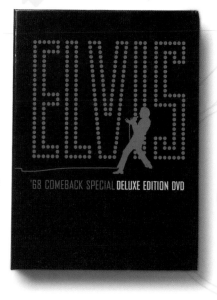
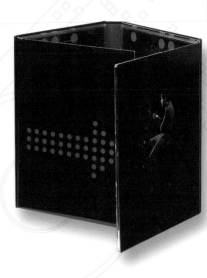

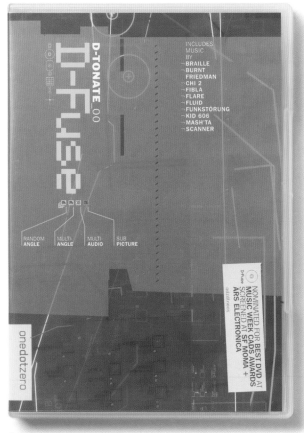

Client: **D-Fuse**
Design: **D-Fuse**
Authoring: **The Pavement**
Interface: **Audio Shriek**
Year: **2003**
Country: **UK**

D-Tonate_00

This DVD really challenges the conventional music-video format. It comprises nine films that have each been recreated in five different versions. These can be randomly accessed on the DVD, along with 10 audio tracks produced by, amongst others, Kid 606, Scanner, and Funkstörung. The result is more than 90 minutes of multiangle films and multiaudio tracks. Using their remote control, the viewer can modify and mix movies. Having five different streams of video for each track means that you can switch between them "on the fly." The packaging is based on the DVD interface, includes a poster printed in metallic green ink. "I think it's essential that the purchaser gets value for money. Although we cannot control the retail cost of the DVD, we can ensure that we spend time and energy producing some interesting packaging," explains Michael Faulkner, designer at D-Fuse. The DVD was nominated for Best DVD at the 2003 Music Week CADS Awards, and has been screened at the San Francisco Museum of Modern Art.

Client: **Island Records**
Design: **Keith Tamashiro at Soap
 Design Co.**
Year: **2004**
Countries: **USA/UK**

DJ Shadow Live!: In Tune and On Time

This is a live-gig DVD and audio CD set for world-famous DJ, DJ Shadow, who toured the world in 2003, playing to thousands. The actual show filmed to make this DVD was performed at the Brixton Academy in London. For the cover package, designer Keith Tamashiro used imagery taken from the DVD, as well as montages that were especially created using everyday American objects placed over a euphoric crowd. The DVD also contains a hidden interview, which is accessed by pressing the cursor up on one of the menus.

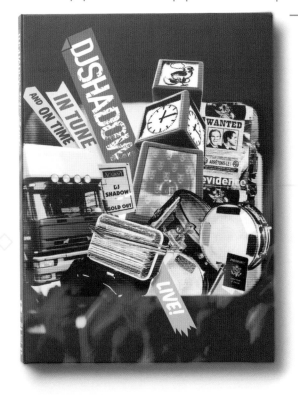

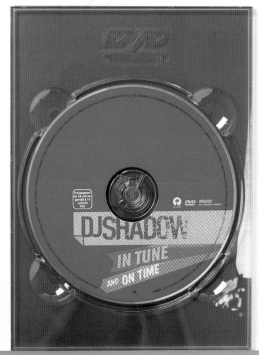

Client: **Expansion Team**
Design: **Servicio Ejecutivo**
Year: **2005**
Country: **USA**

Expansion Team showreel

Expansion Team is a music company that writes original music for TV, film, and video games. This Digipak DVD, audio CD, and 40-page booklet is a showreel of recent TV commercials and other projects for their clients, which include Nike and VH1. Shrink-wrapped to the exterior of the Digipak is a bonus DJ mix that contains old and new releases from the artists at Expansion Team, and was mixed by Scott Hardkiss, also at Expansion Team. "The DVD is meant to be as simple as possible, so it doesn't have any interface or menus—it automatically starts on insertion," explains designer Tatiana Arocha. "There is an opening animation which I designed and animated based on the style of the exterior cover of the Digipak." The main image used on the package is a photograph of a wall in a park in New York City near Expansion Team's office. If the viewer is patient, there is a treat at the end of the DVD: if you continue watching after the formal "ending," there is a bonus piece for Nike's NikeLab Speed project. The package is a six-panel Digipak with a center pocket, and is printed reverse for a matte finish.

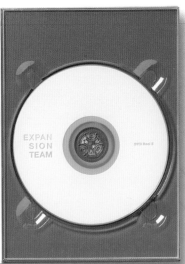

Physical

"The experience of opening up a cool package with unexpected surprises built into the product makes the user-experience more special."

Erwin Gorostiza, Sony Urban Design Director, Sony

Client: **IdN**
Design: **IdN**
Year: **2004–2005**
Country: **Hong Kong**

Flips magazine: issues 6, 7, and 8
Flips is a magazine/book published by IdN. Included with each issue is a specially made DVD. Flips 6: Celebrities is an in-depth exploration of how effective it is to use celebrities in advertising campaigns, and features adverts from around the world on DVD. Flips 7: Animation focuses on character and figure design, and the DVD contains two hours of animation. Flips 8: Moview is a complete overview of all aspects of the contemporary movie scene. The DVD comprises stunning moving images and motion graphics, including excerpts from the films iRobot and The Stepford Wives.

Client: **Lemon Jelly**
Design: **Airside**
Year: **2004–2005**
Country: **UK**

'64-'95

This DVD was made to accompany the release of the '64–'95 album by Lemon Jelly. The album contains nine tracks, each of which is based on a music sample from the years 1964 to 1995. To reflect the diversity of sound on the album, designers at Airside made a DVD containing nine different animation styles, one for each song. Lemon Jelly has very firm ideas about the look of their packaging. They do not like jewel cases or any plastic-based packaging, so both had to be avoided if at all possible. The brief, therefore, was to design a nonplastic box that contained extras in the form of postcards, a poster, and a limited-edition gatefold CD. A logo containing patterns and images from all the DVD tracks was created for the album name. This design is carried across the CD, vinyl, and DVD packaging. There are also lots of hidden treats within the animations themselves.

Client: **Schweizerischer Bühnenverband (Swiss Theater Association/SBV), in conjunction with the Zurich School of Art and Design (HGKZ) and the Zurich School of Music, Drama and Dance (HMT)**
Design: **unfolded**
Year: **2004**
Country: **Switzerland**

Theaterblut: Der Film

Theaterblut: The Movie has a subtitle that reads "People living on, behind, and for the stage with all their heart and soul." It is an interactive DVD, created by The Swiss Theater Association and its collaborators, that conveys impressions and insights into the world of the stage through the medium of film, and allows the viewer to enter spaces that normally remain closed to outsiders. The title The Movie refers to the Theaterblut project as a whole, and incorporates the Web site (www.theaterblut.ch), a diary, and a multiuser game. In 2004, design company unfolded was commissioned to create the packaging for the DVD. To give it diversity and density, designer Friedrich-Wilhelm Graf decided to deviate from the archetypal DVD package and created these two different versions. The first is the DVD alone, which is packaged in a clear jewel case accompanied by a booklet, the front of which also doubles as the cover. The second, a more extensive package, includes the DVD, a diary, and a number of badges and stickers. This is all housed in a simple card box sealed with a sticker containing the title.

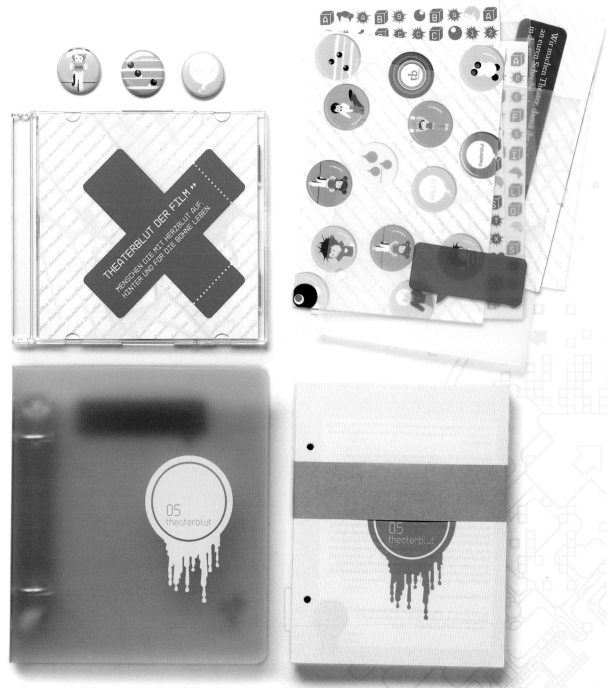

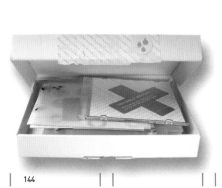

Client: **Specialten**
Design: **Up The Resolution**
Sound Design: **Soviet Science**
Year: **2005**
Country: **UK**

Specialten

Specialten is a bimonthly collection of short films, music videos, and exclusive interviews focusing mainly on music, film, animation, and design. Up the Resolution was asked to create a package for Issue 8, which features Lemon Jelly, Trevor Jackson, and Unkle, among others. The designers were given some basic guidelines; they had to convey the feeling of moving around a space, which had been established in previous issues. The idea behind the packaging was to create as much of a visual synergy with the DVD animation as possible. "We wanted to create the same atmosphere for all elements of the project," explains designer Merlin Nation. "We designed a simple logotype that inspired the intro animation on the DVD, and this became a repeat element in all aspects of the project. We felt that all of the elements should combine to make a strong, coherent visual identity for the magazine." To this end, the imagery used on the packaging is taken directly from the animation itself. The typeface used is a version of Courier, but used without aliasing so it becomes pixelated, and the cover is printed on reverse board.

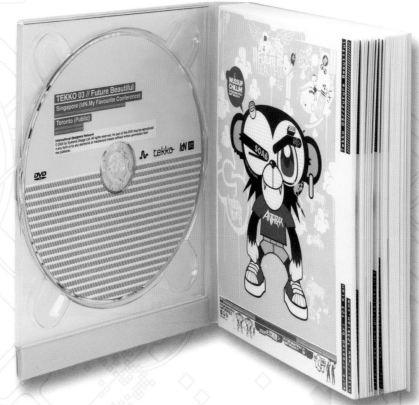

Client: **Tekko**
Design: **IdN**
Year: **2004**
Country: **Hong Kong**

Tekko 03: Future Beautiful

Tekko is an organization of individuals working in design and/or visual culture industries, including Free the Department, Planet Pixel, Sweden Graphics, and Phunk Studio. As part of IdN's My Favourite Conference, which was held in Singapore in May 2004, the Tekko group held an exhibition. This DVD and postcard set, Tekko 03: Future Beautiful, featuring work shown at the exhibition, was created to accompany it. The neat, compact package, with a book-style cover in a bright green gloss finish, comprises a deck of illustrated postcards and an accompanying DVD containing 30 minutes of motion graphics.

Client: **EMI Music Catalogue Marketing**
Design: **Darren Evans for the Red Room
 at EMI**
Interface: **Abbey Road Interactive**
Research: **Tanzy Burrill**
Year: **2002**
Country: **UK**

Ziggy Stardust And The Spiders From Mars: The Motion Picture

This DVD features a documentary film of David Bowie's concert in July 1973 at the Hammersmith Odeon, London, in which the singer "killed" Ziggy Stardust without having told the band or tour organizers (he still had US dates on the tour to complete, but these were canceled). The live footage is cut with scenes from outside the venue and backstage. The brief for the package involved watching the film, learning the background to the concert, and researching the career of David Bowie before and after 1973. Designer Darren Evans was also given a copy of a film poster and the original vinyl artwork that featured an image of David Bowie smoking on the cover. This image was to be used so that Bowie fans would recognize the product. Because the package also had to help the listener relive the moment of Ziggy's death, as well as give them something to treasure, it included a pull-out poster, one side "advertising" the gig, and the other side covered in press clippings from the aftermath, a ticket stub for the gig, and a fanzine-like booklet. Extras on the DVD include a commentary by director D. A. Pennebaker, and music producer Tony Visconti, as well as a DVD-ROM section that includes a calendar, screen saver, desktop pictures and icons, and Web links.

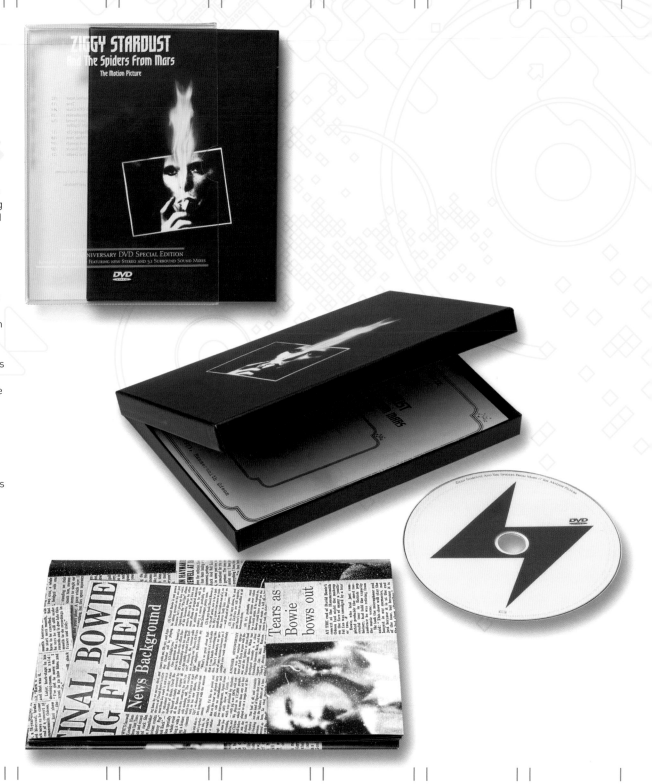

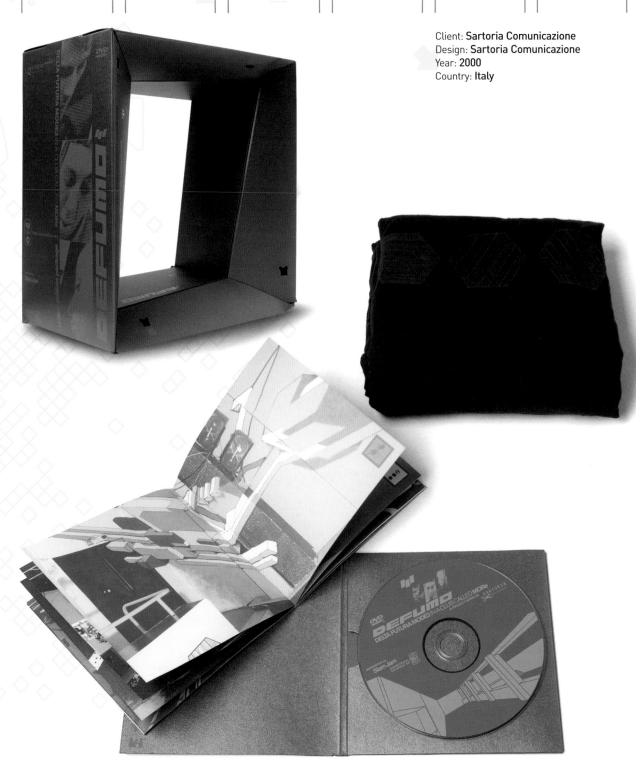

Client: **Sartoria Comunicazione**
Design: **Sartoria Comunicazione**
Year: **2000**
Country: **Italy**

Defumo

Defumo is a documentary film about three graffiti artists working together in More, a club in Modena, Italy. Defumo is the collective name for the three artists: Delta, Futura2000, and Mode2. This promotional DVD contains a mix of music, film, video, and painting footage, as well as interviews with the artists and insights into the way they work. The overall idea was to tell the story of three legendary graffiti artists who come together for the first time to work on a project in unison. Designer Gilles Cenazandotti at Sartoria Comunicazione created the packaging and interface for the DVD. The Defumo project included not only a DVD, but also a series of limited-edition T-shirts designed by the three artists, and a Web site (www.defumo.org). The cardboard package folds into four areas, containing the three T-shirts and the DVD. UV serigraphy was used to print black on black.

Client: **Now on DVD/Victor Entertainment, Inc.**
Design: **Masaru Ishiura at TGB Design**
Interface: **Masaru Ishiura at TGB Design**
Year: **2003**
Country: **Japan**

Cube World: Music is our Message?

This special package marks the release of music artists Cube World's videos on DVD. It also includes remixes of some of their tracks by music legends Logan in the US, and New Stench in the UK. TGB Design had worked on many previous Cube World and Cube Juice releases, so it was given creative freedom. The disc itself is housed in a simple CD-size jewel case, and features imagery indicative of all Cube World's releases. The inclusion of a "toy" meant that a larger box package had to be created to accommodate both items, and this features the high-color, character-filled imagery that can be seen on other Cube products.

Client: **One Two School**
Design: **Masashi Ichifuru at TGB Design**
Year: **2003**
Country: **Japan**

Snail Ramp: Noise Zero-G Tour 2002

For a fan of Snail Ramp, a Japanese Ska-Core/Punk band, this collectible DVD and added extra release is a real treat. It was created by designers at TGB design for the release of a special-edition DVD that contained footage of the band's 2002 tour. As well as the DVD, included in this boxed package is a T-shirt and cap bearing the band's logo. This is all housed in a specially designed card-based box, on which the band's name and other information has been silk-screen printed. This package was a limited edition and released in Japan only.

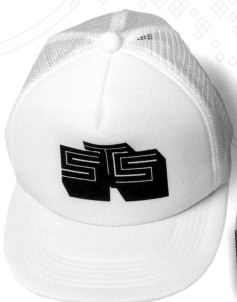

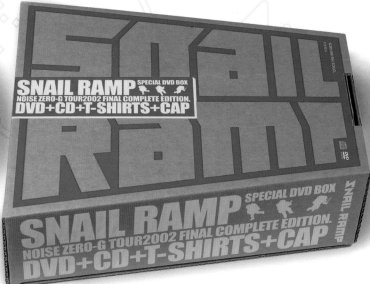

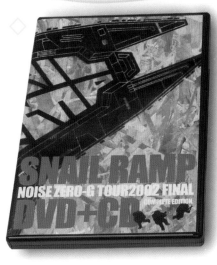

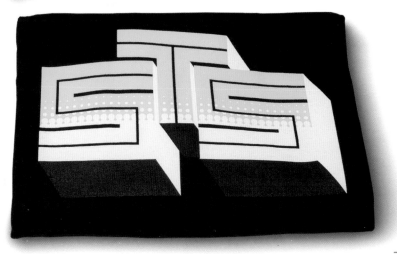

Client: **Parlophone**
Design: **J. C. Hewlett/Zombie Flesheaters**
Year: **2002**
Country: **UK**

Gorillaz: Phase One: Celebrity Take Down

The idea for this package was to make it "special" in terms of design and materials, and as a result, the designers paid a lot of attention to finding the right materials. The package includes a booklet that has been given a leather-bound effect through using a leather-effect paper and text embossed in gold. In addition, an old-style treasure map, created using the old "coffee trick" together with a Stucco embossing effect, is included, along with 22 stickers. The DVD is housed in a clamshell box printed CMYK with gloss laminate finish outside.

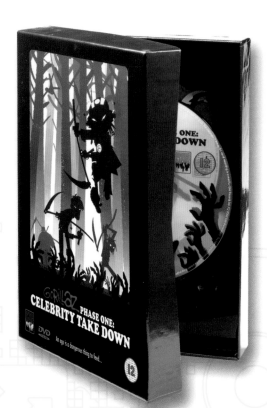

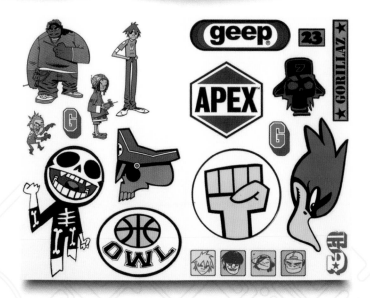

Chris Bilheimer, Graphic Designer, 3, USA

When approaching the design of a DVD cover what inspires you?
The most important thing is to try to encapsulate what the DVD is about. As people can't preview the DVD content, the packaging is the only link they have to what is inside. You don't want anyone to feel ripped off if the packaging is slick, but the DVD is crap. That doesn't mean the package should always include screen shots on it, but it should definitely give people a sense of what is inside. If you get too experimental, without some clue as to what the film is about, people will be less likely to buy the DVD.

How does it compare with CD album cover design?
It is pretty similar, although I do feel that there is more emphasis to tie the art in with the rest of the DVD content. With a CD, you need to capture the mood of the music, but it doesn't have menus and video to integrate with. A DVD package should have a similar feel as the rest of the visuals. I love a DVD that has a unified feel to it. The menus, video, and package should all work together. The Futurama box sets are amazingly unified in design, menus, and content, and as you delve further into the DVDs, the more excited you get.

What role do you think the designer plays as a marketer?
It totally depends on who you are trying to reach. The larger the audience, the more the packaging has to "sell" the product. If you are shooting for a built-in niche audience, then you have a lot more freedom from worrying about the marketing aspect.

What can designers, or those in the music industry, do to encourage people to continue to buy albums on CD, rather than download? Do you think that including DVDs helps?
I don't know. Common sense would have you believe that getting more content for your money would be more desirable. But often the CD will cost a little bit more, and the DVD feels like an afterthought, which I think would turn consumers off. If the extra DVD contains one music video and a Web link, I don't think anyone will care. But honestly, I have no idea how it really affects the consumer. If I did, I would rule the music industry, which, sadly, I do not.

In the event that films do become downloadable, what do you think designers could do to encourage people to continue to buy films on DVD?
I think people will always want to hold something. Since watching a movie on your computer kinda sucks, the quality of a DVD is pretty desirable. I think people download things they are curious about, but would probably never go out and buy. If they love it, they will often go out and buy a copy of it. The tactile sensation is not going to go away, but downloading will certainly take a bite out of the packaging audience. People still buy newspapers and magazines, even though a lot of that content is online.

What can be done to make DVD packages more distinctive or innovative?
Making alternative packaging cheaper is the only way you will see variation in the marketplace. There are very few altruistic DVD publishers. They need to make money, and they rarely want to spend an extra 50 cents on packaging because it affects the bottom line. Many times, elaborate packaging is a signal that the movie needs more help in selling it, and it is possibly a piece of crap on the inside. I think that Johnny Mnemonic had an elaborate VHS case because it was a crap movie.

Mike Faulkner, Art Director, D-Fuse, UK

When approaching the design of a DVD cover, what inspires you?
The contents of the DVD. I like to use elements from this.
I like image sequences—they remind me of 16mm film strips.

How does it compare with CD album cover design?
It is very similar. CD is now considered a "dead" format by
record labels. DVD cover design could take over for a short
while. Sleeve design is important even if the product is not
a "hard" copy. Also, print design has some beautiful qualities
that are not available on Web and video: special inks, varnishes,
and the ability to print on interesting materials.

**How much of a role do you think the designer plays as
a marketer in the retail environment?**
The same role as a record sleeve designer. Good design
is always an asset.

**What can designers, or those in the music industry, do to
encourage people to continue to buy albums on CD, rather
than download. Do you think that including DVDs helps?**
Yes, this is the vision for many major labels. We have just
completed a Beck deluxe DVD. This is an interesting quote from
musician Beck. "Everyone's talking about what the future of
recorded music is in terms of downloading songs, and the
implications of people not buying CDs, and what happens to
the artwork. But if you're breaking music down to where it's
encoded files, you can easily put visual information into that.
The artwork isn't something that's printed on the CD case—it's
something that exists in the music. That's the whole concept
behind the DVD."

**In the event that films do become downloadable, what do you
think designers could do to encourage people to continue to buy
films on DVD?**
Maybe including specials like posters as we have in our
D-Tonate 00 DVD, or as in the Beck deluxe DVD, which also
included a book.

**DVDs largely remain packaged in different variations of the
standard plastic Amaray case covers. What can be done to
make these packages more distinctive or innovative?**
Screen printing, special inks, and varnishing onto the Amaray.

**If there was no limit to the budget, how would you design
a DVD cover?**
I would probably still work with a clear Amaray, although
I would use special inks and varnishes, or maybe a special
material Amaray, like a metal or glass Amaray, but it should be
hardwearing. My thoughts are that, often, the special packaging
ends up tatty and falling apart. A key quality with Amaray is that
it is waterproof and hardwearing.

Richard Brown, Producer, Palm Pictures, USA

What do you think about DVD packaging design—what makes a good one or a bad one?
I think the standard DVD packaging is fundamentally bad, and the best DVDs are the custom-packaged ones, like the Directors' Label ones or most of the Criterion collection releases.

What is it about them that makes them better?
They are double size and better-made boxes, and tend to feel more collectible.

And what about menu design?
Menus on feature film DVDs should mostly be functional and simple, although on compilation DVDs, like the Directors Label titles, there is an opportunity to give the menus an identity whereby they almost become a feature of the DVD in themselves. The Abbey Road design team are doing great work in this area.

Downloading music is becoming increasingly popular, and there is talk of this happening with movies. What can the film industry do to encourage people to continue to buy films on DVDs?
I tend to buy DVDs that are well packaged and designed, and those with significant, well-produced extra content. Pretty much every title in the Criterion collection falls into both these categories, and as a result people want to own and collect their releases rather than downloading or renting them.

What is your all-time favorite DVD and why?
Criterion's The Battle of Algiers three-disc set. They took a great, unavailable movie, did a beautiful transfer, added all the existing extra material relating to the film on a second disc, and then produced an entire disc of new content for the third disc. The whole thing was perfectly packaged and presented, and is a must-have for any film lover.

Contact Details & Acknowledgments

Contact Details

ABVK www.abvk.de
Adjective Noun www.adjectivenoun.co.uk
Airside www.airside.co.uk
Anchor Bay Entertainment UK Ltd www.anchorbay.co.uk
Antoine+Manuel www.antoineetmanuel.com
Axel Isberg www.axelisberg.com
Barbara Rosenthal/eMediaLoft.org www.emedialoft.org
Big Active www.bigactive.com
BLEED www.bleed.no
Blue Source www.bluesource.com
Bureau Des Videos www.bureaudesvideos.com
Büro Dirk Rudolph www.dirkrudolph.de
C505 http://projects.c505.com
Chris Bilheimer www.bilheimer.com
Colette www.colette.fr
Craftyfish www.craftyfish.com
C-TRL Labs Inc. www.c-trl.com
David Lee/2nd round productions www.davidchoonglee.com /
www.2ndroundproductions.com
De Designpolitie www.designpolitie.nl
DED Ass www.dedass.com
The Designers Republic www.thedesignersrepublic.com
D-Fuse www.dfuse.com

Dirk Rudolph www.dirkrudolph.de
DWTC balgavy www.dtwc.at
Erbe Design www.erbedesign.com
FJD www.fjd.jp
Form www.form.uk.com
Four5one www.four5one.com
Frank Olinsky www.frankolinsky.com
Fry-Guy/5ALYUT www.5alyut.com
Funny Garbage www.funnygarbage.com
Gabor Palotai Design www.gaborpalotai.com
Gentil Eckersley www.gentileckersley.com
GRV Co., Ltd www.groovisions.com
Honest www.stayhonest.com
IdN (International Designers Network) www.idnworld.com
Jewboy Corporation™ www.jewboy.co.il
Kai Turner/mediapollen limited www.mediapollen.com
KesselsKramer www.kesselskramer.com
Kranky www.kranky.net
Lars www.designbylars.com
Likovni studio www.list.hr
Lobo www.lobo.cx
Locografix www.locografix.com
Made Thought www.madethought.com

Marok www.lodown.com
Masashi Ichifuru (TGB design) www.tgbdesign.com/ichifuru
Meat and Potatoes, Inc. www.meatoes.com
Neasden Control Centre www.neasdencontrolcentre.com
Neuron Syndicate Inc. www.neuronsyndicate.com
Non-Format www.non-format.com
North www.northdesign.co.uk
Palm Pictures www.palmpictures.com
Pandarosa www.pandarosa.net
Pao Paws www.paopaws.com
Paramount www.paramount.com
Patrick Duffy www.utan.co.uk
Peacock www.peacockdesign.com
Pfadfinderei www.pfadfinderei.com
Philip O'Dwyer www.philipodwyer.com
Point Blank Design www.pointblankdesign.co.uk
RAYR www.rayr.net
Reala AB, Sweden www.reala.se
Remote www.remoteondvd.com
Rik Bas Backer/Change is Good rikbb@wanadoo.fr
robert.daniel.pytlyk design www.theplantation.ca
SafePlace www.safe-place.net
Sagmeister Inc. www.sagmeister.com

Sartoria Comunicazione www.sartoria.com
Seb Jarnot www.sebjarnot.com
Servicio Ejecutivo www.servicio-ejecutivo.com
Segura Inc. www.segura-inc.com / www.5inch.com
simplefficace-design/Martin Lavergne
www.simplefficace-design.com
Soap Design Co., LA www.soapdesign.com
Sockho www.sockho.com
State Design www.statedesign.com
Syn Corporation/Syn Entertainment
www.synentertainment.com
Unfolded www.unfolded.ch
Union Design www.union.no
Universal Everything (Matt Pyke) www.universaleverything.com
Up The Resolution www.uptheresolution.co.uk
visomat inc. www.din-av.de
WeWorkForThem www.weworkforthem.com
Winter & Winter www.winterandwinter.com
Work in Progress www.workinprogress.com
Yacht Associates www.yachtassociates.com
Zip Design www.zipdesign.co.uk
Zombie Flesh Eaters (Flesh Eaters Ltd) www.zombie.uk.com

Acknowledgments

Many thanks to all the designers around the world who contributed to this book. It was a great title to put together and would not have been possible without the help of you all. Thanks again to Simon Slater for an excellent design job, and to Xavier Young for the photography. Also to Lindy Dunlop, Jane Roe, and Luke Herriott at RotoVision for their help in the production of this book. Special thanks to Jason. This book is for Mum.

Index